Front cover (main photo): Kinkaku-ji Temple's Golden Pavilion.

Front cover (bottom, left to right) Kamigamo Shrine priests; Ryoan-ji Temple's Zen garden; Tea served at Jonan-gu Shrine; Torii gates at Fushimi Inari Shrine; *Maiko* apprentice geisha.

Front flap Katsura Imperial Villa tea pavilion.

Spine Lotus flower at Hokongo-in Temple.

Back cover (main photo) Kinmata kaiseki restaurant and *ryokan* inn.

Back cover (below, left to right) Cast-iron *tetsubin* kettle for heating water in the sunken hearth of a tearoom; *Maiko* with cherry blossom tassels; Zen garden at Komyo-in Temple.

Front endpaper Torii gate tunnel on Mount Inari.

Back endpaper Autumn at Nanzen-ji Temple.

Page 1 Hozu River excursion in Arashiyama.

Pages 2–3 Symbolic *tatezuna* sand cones at Kamigamo Shrine (left); Autumn tea at Shinnyo-do Temple (right).

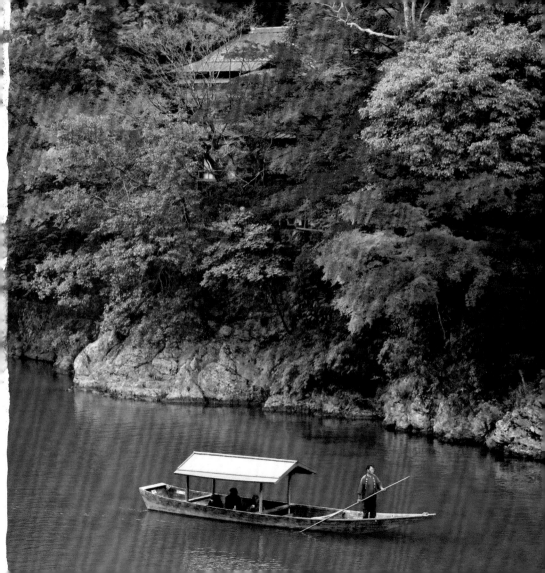

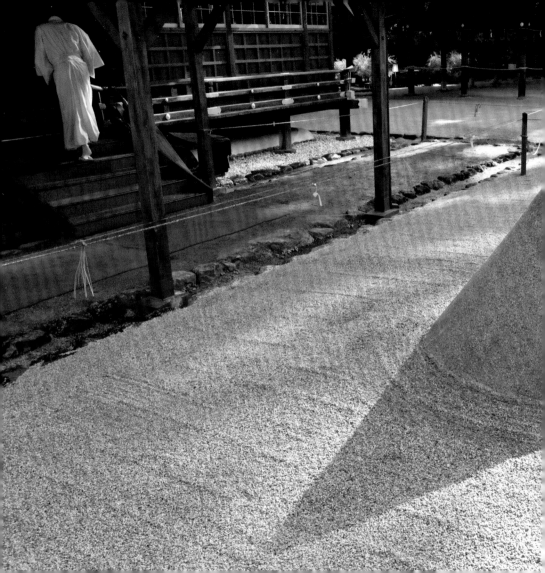

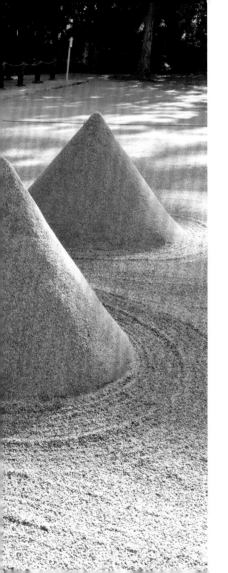

The Little Book of
Kyoto

Ben Simmons

TUTTLE Publishing

Tokyo | Rutland, Vermont | Singapore

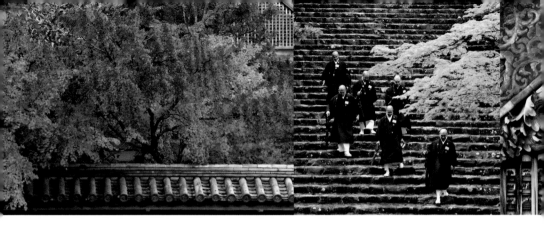

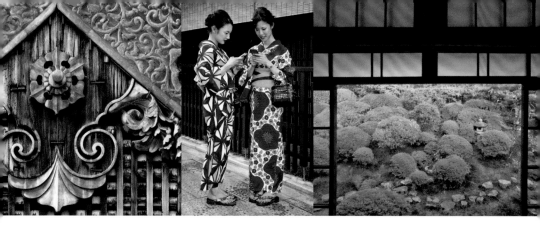

Above, left to right Tenju-an Temple; Monks at Jingo-ji Temple; Ninomaru Palace at Nijo Castle; Summer *yukata* kimono in Gion; Spring garden at Anraku-ji Temple.

Below left *Miko* shrine maidens at Jonan-gu Shrine.

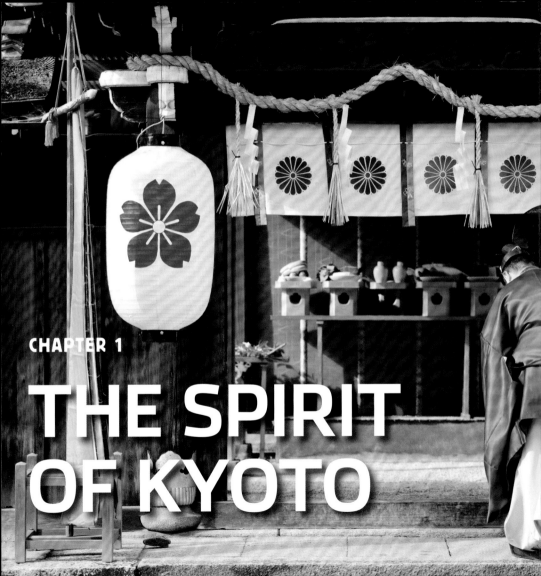

THE SPIRIT OF KYOTO

From the excitement and pageantry of its plentiful festivals to the timeless Zen calm of its sacred temples, the spirit of Kyoto emanates from a rich heritage and deep pride as Japan's imperial capital for more than a thousand years. Kyoto's confidence in its unparalleled history and traditions is further enriched by the vital energy generated by ongoing education that flows steadily from the city's abundance of colleges, universities, training schools, and cultural centers. Kyoto's dedicated teachers insure a resilient spirit and resurgent energy will ultimately achieve a crucial balance of historical legacy facing the challenges of modernity.

Kyoto's ethos is reflected in the artful arrangement and detailed attention afforded every aspect in daily life: the fresh flowers at a neighborhood shrine, the elegant presentation of cuisine for both visual and culinary delight, the precise rituals of the city's legions of monks, gardeners, tea attendants, Shinto priests, and skilled craftspeople. Even shopping chores amidst Kyoto's historical markets and generations-old shops can seem a spiritually enhanced adventure. The spirit of Kyoto nurtures its residents and inspires the Japanese people throughout the archipelago, while touching the lives of perceptive visitors from all over the world.

A *kannushi* priest in ceremonial costume at Hirano Shrine.

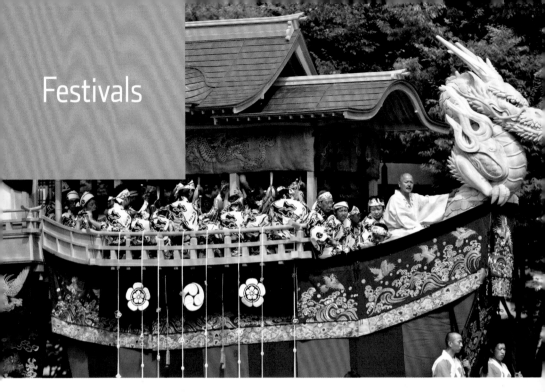

Festivals

Above The Ofune Hoko float during the Gion Ato-Matsuri Parade.

Right Participants in Gion's Hanagasa Flower Hat Procession.

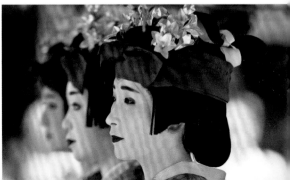

Kyoto's *matsuri* festivals are held throughout the year. Every month, nearly every week, and at times it seems on any day, there is a traditional *matsuri* or holiday celebration under way somewhere in the city. Kyoto festivals and special events are so plentiful that the monthly *Kyoto Visitor's Guide* can hardly fit all the details into the magazine's thirty pages. Kyoto's most famous festival, the Gion Matsuri, was recently added to UNESCO's Intangible Cultural

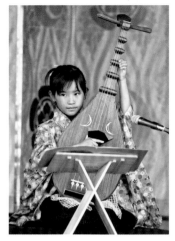

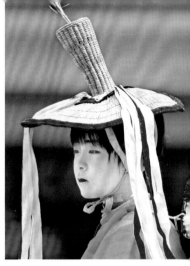

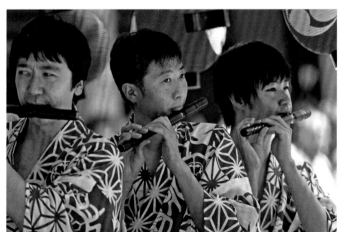

Above left A performance of the Japanese *biwa* lute at Yasaka Shrine.

Left Musicians on a Gion Festival parade float on Shijo-dori Avenue.

Above A *chigo* sacred child on horseback.

Below A traditional dance with *sensu* folding fans at Heian Shrine.

Right A Gion Festival parade on Shijo-dori.

Center right A procession of *taimatsu* torch bearers.

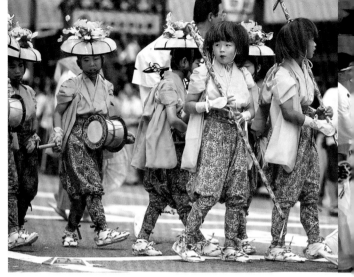

Right A Gion Festival parade on Shijo-dori.

Center right A procession of *taimatsu* torch bearers.

Heritage list. Begun as a purification ritual to ward off deadly plagues more than 700 years ago, the Gion Festival transforms the city for the entire month of July. Extensive preparations by craft guilds, merchant families, and neighborhood organizations proceed amidst performances of traditional music and theater, culminating in the Gion Matsuri's two epic parade processions. Each of the towering *hoko* floats and richly adorned *yama* floats, with their strikingly attired attendants, are really too overwhelming to fully absorb before the next amazing display is pulled or carried into view.

Kyoto's Aoi Matsuri, celebrated since the 6th century, is the world's oldest festival and continues largely unchanged, a sedate procession of chaste elegance and period costume celebrating Heian culture. The Jidai Matsuri, Kyoto's "Procession of the Eras," begins with ceremonial services at sacred Heian Jingu Shrine,

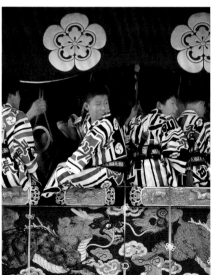

Left Boys in festival attire ride atop a *yama* pull-style float.

Below Young *taiko* drummers on parade.

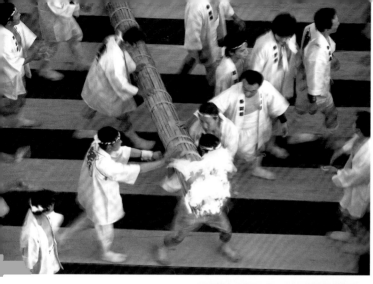

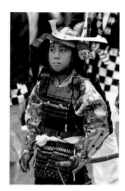

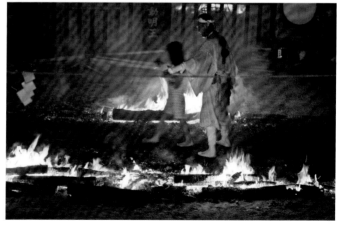

where the spirits of Heian's two deified emperors are transferred to portable *mikoshi* shrines that are accompanied by marchers in traditional costumes from each historical era. The reverential and celebratory procession makes its circuitous way to the Imperial Palace before returning through Heian Jingu's iconic towering torii gate.

Shrines

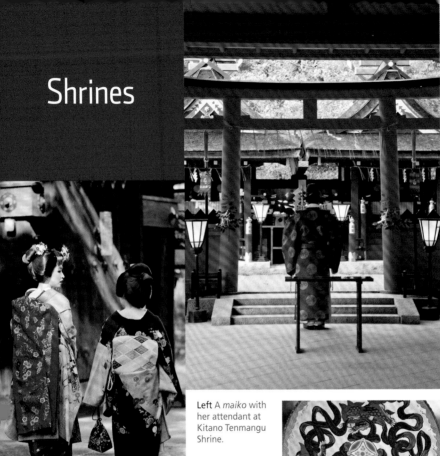

Left A *kannushi* priest at the inner shrine of Yoshida Jinja.

Left A *maiko* with her attendant at Kitano Tenmangu Shrine.

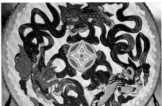

Left An artfully decorated ceremonial drum at Hirano Shrine.

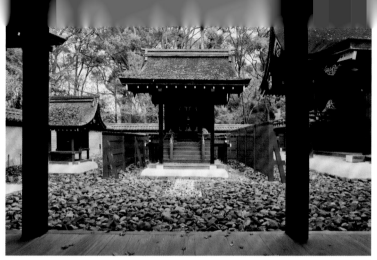

Kyoto has hundreds of Shinto shrines located throughout the central city and in the surrounding mountains and southern districts, usually denoted by a simple but distinctive torii gate. Shinto is Japan's native animistic religion, with an almost phobic concern for purity, divinity, and secretive ritual. Layers of gates and fences ward off the impure and protect the devout. Emphasizing harmony with nature and spiritual deities, the Shinto *kami* sacred spirits are traditionally enshrined in beautiful natural locations. Kyoto's shrines have preserved green sanctuaries, from vestige to forest, amidst the city's modern configuration.

Kyoto's shrines range from the austere, with unadorned and unpainted timbers, to striking vermilion lacquered halls with decorative fixtures. Some shrine architraves are carved with mythical creatures, and the pristine grounds enclose the remnants of the natural landscape. All elements, from architecture to garden, reflect dedicated craftsmanship. Even the metal fittings of a shrine's roof truss are fashioned by highly skilled Kyoto craftsmen,

Top left The outer shrine at Shimogamo Jinja.

Top right A respectful appeal to the shrine's deity.

Above *Shinsen* offerings of fish, rice, sake, and salt.

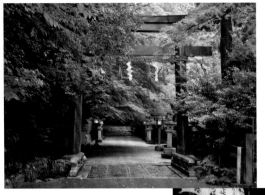

Right A vermilion bridge over the Kamiya River at Kitano Tenmangu Shrine.

Above A torii gate with *shimenawa* straw rope denotes the sacred entry to Ota Shrine.

Right *Chochin* paper lanterns inscribed with donors' names at Kanja Densha Shrine.

created from a thin sheet of copper, shaped with a great variety of hammers and punches, then brushed with lacquer and covered with gold leaf, before finally rubbed to a perfect finish. Wooden lattice at some Kyoto shrines may be laboriously treated with thirty coats of lacquer. Yet the most striking feature of Kyoto shrines is their spartan emptiness, perhaps offering an inspiring acuity, a symbolic counterpoint to lives where every nook and cranny is filled with distractions.

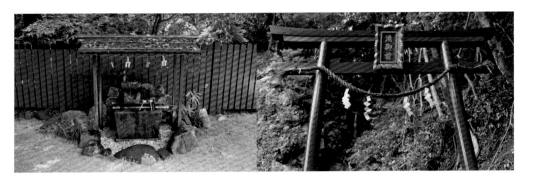

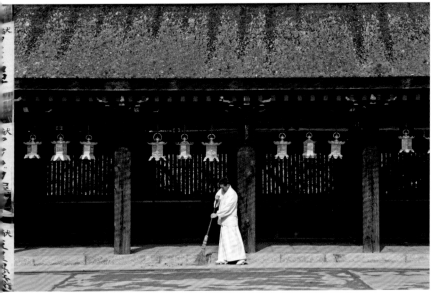

Above left A *temizuya* water font for purification at Kawai-jinja.

Above right A torii gate and sacred waterfall at Matsuno Taisha Grand Shrine.

Left A *kannushi* priest sweeps the already spotless courtyard alcove at Kitano Tenmangu Shrine.

Temples

Kyoto's Buddhist temples house much of the ancient capital's rich trove of artistic treasures and Buddhist learning. The city's hundreds of temples and thousands of monks continually enrich cultural traditions such as tea, ikebana, and calligraphy. The hushed protective atmosphere of Kyoto temples can serve as temporary sanctuary ("Be a nun for a day" suggests one), or templates for focused contemplation, or just to set the mind free for a precious moment. The calm of a temple garden in Kyoto might offer a perfect perspective on Buddhism's insights into the transitory and ephemeral nature of … everything.

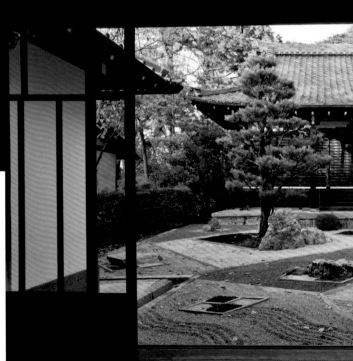

Above The perfectly round "Window of Zen Awakening" at Genko-an Temple.

Right A contemporary *karesansui* dry landscape garden at Shinnyo-do Temple.

Kyoto's temples are also a huge factor in the economic well-being of the city. From the makers of *nenju* Buddhist prayer beads to the countless other scores of skilled craftsmen, gardeners, and support staff, Kyoto's related businesses, restaurants, and hoteliers all depend heavily on the seemingly never-ending commercial

Left A roofed gate amidst autumn colors at Komyo-ji Temple.

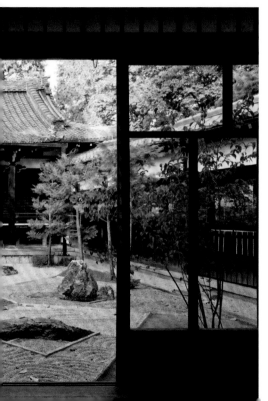

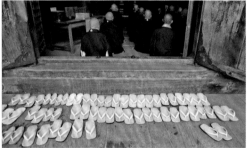

stream of visitors, whether pilgrims or tourists, intent on seeing Kyoto's fabled temples. A war between city officials and Kyoto temple abbots that raged from 1985 until 1987 over tax regulations found major temples closed to all for long enough to hurt both temple and city coffers. The government finally raised the white flag and the great wooden gates of Kyoto's temples were reopened.

Above An assembly of monks at the Kondo Hall of Jingo-ji Temple.

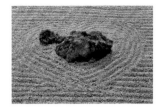

Above Romantic raking at Chishaku-in Temple.

Below A procession of Chion-in priests at the Daiden Grand Hall.

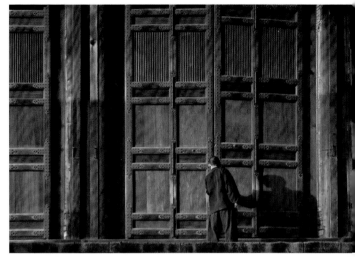

Above A monk closes the great wooden doors of Chion-in's Hondo Hall.

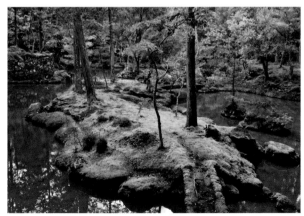

Left An Elysian islet in Ogonchi Pond at Saiho-ji, popularly known as the Moss Temple.

Right Draped *noren* curtains radiate a rainbow amidst winter white on the slopes of Ichijoji.

Below Cherry blossom beauty at Bishamon-do Temple.

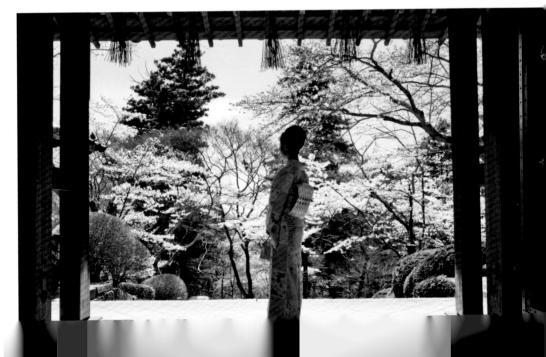

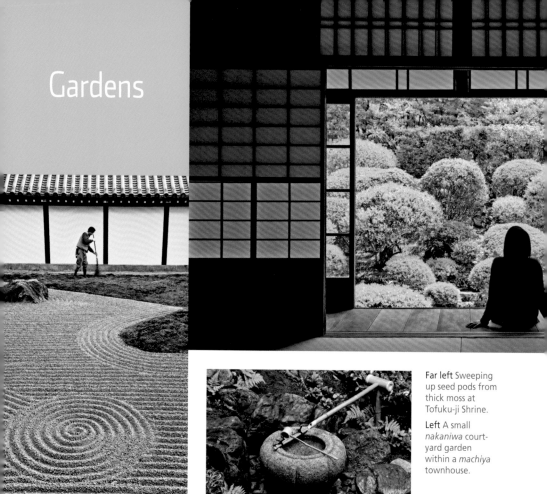

Gardens

Far left Sweeping up seed pods from thick moss at Tofuku-ji Shrine.

Left A small *nakaniwa* court-yard garden within a *machiya* townhouse.

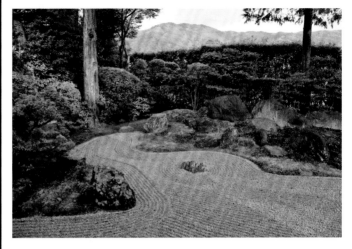

Above Anraku-ji azaleas color the gardener's composition.

Above right Ingenious *shakkei* garden design "borrows" the distant scenery of Mount Daimonji at the hilltop Shinnyo-do Temple.

The city of Kyoto features the country's finest concentration of traditional Japanese gardens. Kyoto's exceptional examples of the best of the Japanese gardening arts include gardens of refined simplicity built upon principles first set forth in the 11th-century gardening treatise *Sakuteiki*, with its ritualized use of natural materials, geomantic impera-tives, and Buddhist allegory. Kyoto contains Zen gardens of minimalist stone and gravel, topiary creations of infinite detail, strolling gardens with masterly crafted ponds and waterfalls, and pristine courtyard gardens glimpsed through lattice frames in every district. The city is also home to Japan's oldest public botanical garden, Kyoto Botanical Gardens, founded in 1924. Even Kyoto's neighborhood vegetable gardens are beautifully laid out, carefully labeled, and meticulously maintained.

Certain Kyoto temple gardens have achieved such fame that they are like sacred cathedrals, so awe-inspiring as to inevitably be overcrowded with worshipers. The ultimate Kyoto garden experi-ence requires looking beyond such

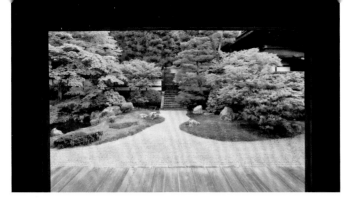

distractions, being aware of a garden's particular charms and one's own temperament, the day's ambience, and the season's special accouterments. Embrace each garden encounter as a unique *ichigo ichie* moment that will not be repeated. The famous rock garden at Ryoan-ji inspired the celebrated English artist David Hockney to obsessively jump about "collecting" pieces of the Zen garden in dozens of snapshots, which he reconstructed as a photo collage, brilliantly applying Picasso's Cubism to photography. Another approach is to just breathe deeply, trust your senses, and clear your mind to savor any Kyoto garden.

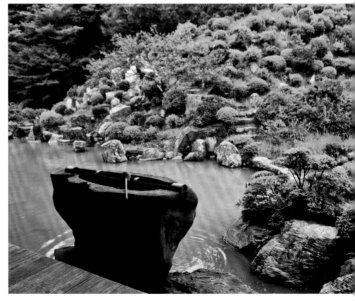

Far left Gozasho Hall's garden view at Sennyu-ji Temple.

Left The simplest of stone bridges at Jonan-gu Shrine.

Below left Crepe myrtle brightens the summer garden at Chishaku-in.

Above left A *sekimori ishi* boundary stone indicates this Daitoku-ji garden footpath is closed.

Above right A stone isle of autumn leaves in the hillside stream at Eikan-do Temple.

Right Tea enhances the contemplation of a 700-year-old *goyomatsu* black pine at Hosen-in Temple.

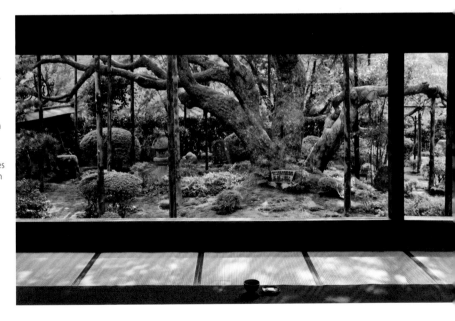

Machiya

Left The *okuniwa* mini-garden at the Higashiyama *machiya* Starbucks is a soothing source of natural light.

Below This renovated *ryokan* inn, reborn as a discreet *machiya* coffee shop, has creative seating options upstairs.

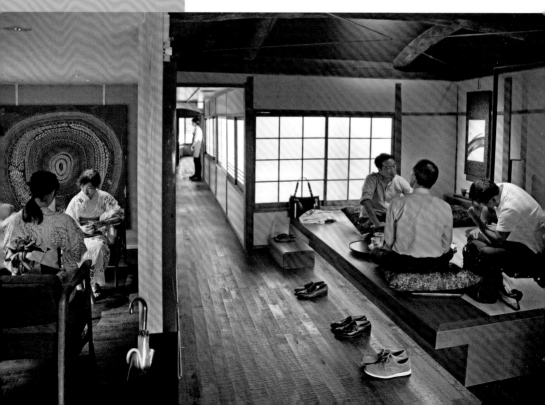

Traditionally, a Japanese *machiya* "town house" was a merchant's place of work and residence, typically with minimal street frontage to cut costs, the business area occupying the front of the *machiya*, the living quarters at the rear of the long narrow structure, and perhaps a small garden space open to the sky. The *kyo-machiya* of Kyoto are some of Japan's finest *machiya* due to Kyoto's outstanding craftsmen and refinement in materials and finish. Kyoto, and the majority of its *machiya*, survived World War II intact, but the "economic bubble" of uncontrolled development wreaked havoc, with perhaps half of the city's pre-war buildings razed, displacing *machiya* for high-rise apartments and parking lots.

An estimated 30,000 *machiya* survive, mostly in central Kyoto, but

Far left A *Shoki-san* guardian deity protects this downtown *machiya*.

Left The *degoshi* lattice bay window of a Kamigyo *machiya* residence.

Below The venerable Kinmata is a *ryokan* inn in Kawaramachi, with fine kaiseki dining.

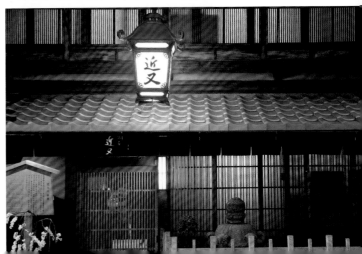

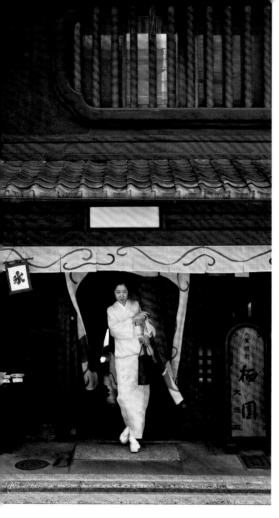

hundreds are torn down each year. A *machiya* "renaissance" spurred by citizens groups, *machiya* experts, and government grants, has helped to slow the demolition, with renovations for non-traditional uses of *machiya* as restaurants, galleries, and shops. A *machiya* Hermes boutique recently opened in Gion, a *machiya* Starbucks in Higashiyama, and an Issey Miyake *machiya* in Nakagyo. *Machiya* restorations that incorporate floor heating, earth-quake safety, and modern plumbing to create more comfortable homes are also helping to save *kyo-machi-ya*. The beauty of Kyoto *machiya* will hopefully endure, with *Shoki-san* demon quellers helping to stand guard above traditional eaves, and the ingenious *battari shogi* folding benches, *kumogata* cloud-shaped windows, and artistic lattice exteriors continuing to grace the city's streets.

Far left A *wagashi* Japanese sweets shop on Rokkaku-dori.

Above left A ceramic *Daikoku-sama* deity insures good fortune for this new *machiya*.

Above An elegant gourd-shaped window with lattice and hand-made *washi* paper in Higashiyama.

Above A *machiya* restaurant with a *battari shogi* folding bench outside.

Left A 19th-century *machiya* with a protective *inu-yarai* curved bamboo fence.

Food

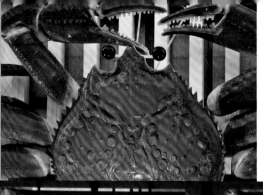

Left A giant *kani* crab display at Kani Doraku in Teramachi.

Below left A tempting display of fresh vegetables outside the Kokoraya restaurant.

With its centuries-deep history as seat of the imperial court and its attendant aristocracy, Kyoto has a rich tradition in the culinary arts. As a city of tradesmen and hard-working craftsmen and women, Kyoto also draws on a wealth of simpler fare, with healthy, nourishing ingredients such as delicious freshly harvested local vegetables, known as *kyo-yasai*.

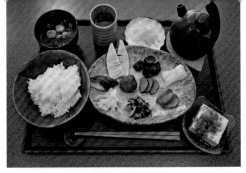

Left A healthy lunch of pickled vegetables, tofu, rice, and miso soup in Sagano.

Below center A "vertical village" of restaurants along the Kamogawa River.

Right An eating/shopping experience at Nishiki Market.

Below Locally grown *kyo-yasai* vegetables are known for their fresh, flavorful nutrients.

A refined, almost obsessive, attention to detail is reflected in both the preparation and presentation of any meal in Kyoto.

The more gourmet kaiseki *ryori*, a seasonal multi-course cuisine served in a striking array of dishware, is probably the ultimate Kyoto dining experience, especially when eaten in a courtyard garden with gleaming wet stones reflecting candles or moonlight. A traveler staying at a temple's *shukubo* lodging might enjoy a special

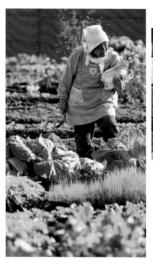

Left A neighborhood vegetable garden in Arashiyama.

Above Preparing *osembe* soy crackers at Nishiki Market.

Right A multi-course kaiseki dinner served at Hakusa Sanso.

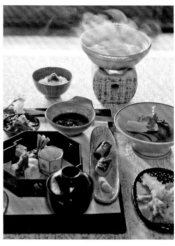

vegetarian *shojin ryori* meal fine-tuned by Buddhist monks, which commonly includes tofu, a Kyoto speciality. *Yuba*, the "skin" from boiled soymilk, is another Kyoto culinary hallmark. For a big appetite and a small budget, Kyoto's many *teishoku-ya* restaurants cater to hungry workers. Typically, *teishoku* "set meals" include a hearty main dish such as grilled fish or pork cutlet served with rice, miso soup, Japanese tea, and pickled vegetables at an affordable price.

Right A lunch of soba buckwheat noodles and fried tempura.

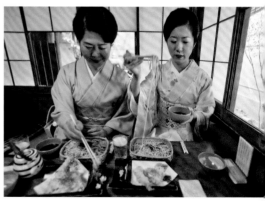

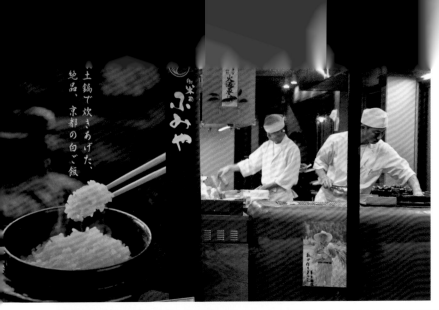

一、土鍋で炊きあげた、絶品、京都の白ご飯

Left A window onto busy Japanese chefs in the Sakyo district.

Below Summer dining terraces overlook the Kamogawa River.

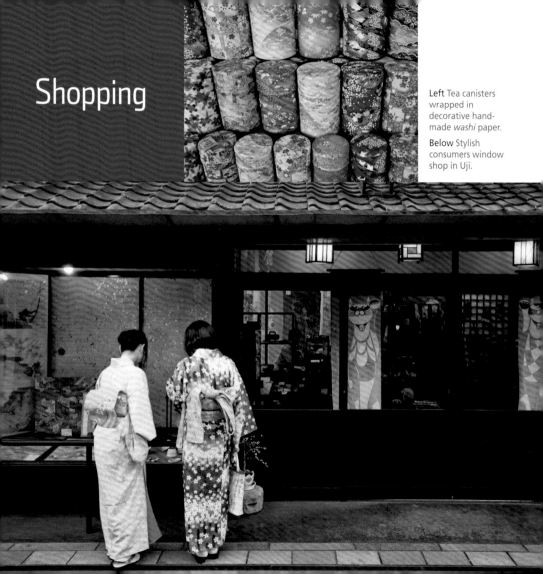

Shopping

Left Tea canisters wrapped in decorative hand-made *washi* paper.

Below Stylish consumers window shop in Uji.

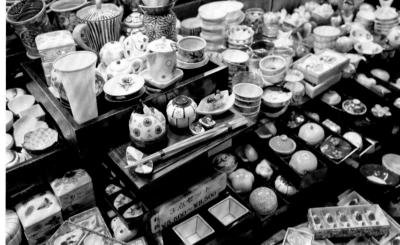

Right A dish for every occasion in a city where meals are also an aesthetic endeavor.

Above A display of traditional silk hand fans.

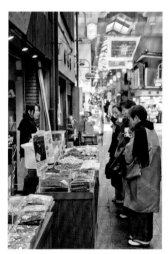

Right Shopping friends sample tea at Nishiki Market.

Shopping in Kyoto can often mean choosing from handicrafts with traditions dating back centuries or visiting a shop that has been a family business for generations. At first glance, certain items such as a brush for applying lacquer may seem relatively simple, but are actually created using extremely complicated and time-consuming processes requiring gifted specialists and unique materials. Kyoto shopping presents a tempting array of handcrafted articles, including static-free boxwood combs, woven baskets, cherry wood molds for sweets, *wagasa* oilpaper umbrellas, bamboo *shakuhachi* flutes, tea containers, *chochin* paper lanterns, cypress wood Noh masks, and silk textiles perfected since the 15th century.

Certain districts and locations in Kyoto have shopping specialties. The streets and lanes between Higashi Hongan-ji and Nishi Hongan-ji Temples

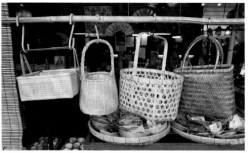

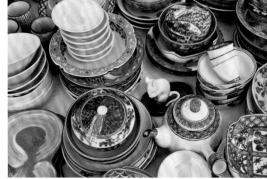

contain many Buddhist altar and paraphernalia shops, candlemakers featuring fluted ceremonial candles, and incense shops with fragrances dating back to the Heian period. The Gojo-zaka area is known for Kiyomizu-yaki pottery and porcelain. The historic neighborhood below the famous Kiyomizu Temple boasts many ceramics shops, studios, and galleries, and hosts the Toki Matsuri Pottery Festival street market each August. The Kyoto Handicraft Center has fine kimono, *ningyo* dolls, traditional cosmetics, and *washi* hand-made paper, as well as craft workshops. The Nishiki Market is considered "Kyoto's kitchen," where shoppers can sample delicious snacks while choosing from vegetables and fruit, tofu, seafood, tea, sake, cutlery, and any shape or size of dishware imaginable.

Above Woven bamboo and reed baskets at a handicrafts shop in Sagano.

Above right A display of ceramics on Gojo-dori during the Toki Matsuri Pottery Festival.

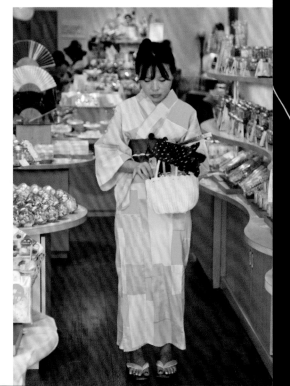

Right A shop in Gion selling *wagashi* sweets and *sensu* folding fans.

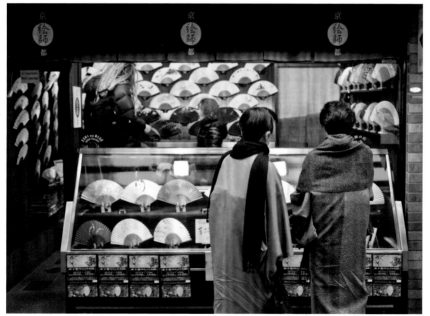

Above left *Wagasa* oilpaper umbrellas at a souvenir shop in Ohara.

Above Chic designer clothing is housed in a traditional *machiya* on Sanjo-dori.

Left Nishiki Market offers much more than edibles alone.

Kyoto Style

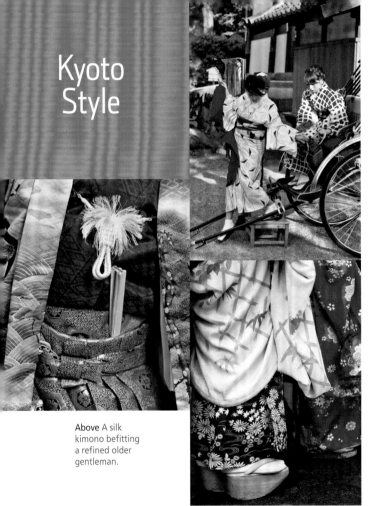

Perhaps the keyword for Kyoto style is kimono. More than anywhere else in the country, the quintessential Japanese kimono, with its inherent elegance and unique grace in motion, can be seen and appreciated in Kyoto every day of the year, not just on special occasions. From the lighter *yukata* of summer to the elaborate silk kimono of Gion's *maiko*, the flowing hues of the traditional robes color the cityscape. A thriving Kyoto industry of kimono rental shops for women and men at reasonable rates (Regular Plan: ¥2,900!) is adding vigor to the city's kaleidoscope of kimono, with more and more international visitors joining Japanese tourists eager to try Kyoto style for themselves.

Dozens of colleges and universities supply a casual contrast of youthful

collegiate fashion (often on bicycles) to Kyoto's thoroughfares, while each of Kyoto's many specialized trades and *shokunin* craftsmen simply must be attired properly, from head to toe, in the appropriate uniform for

Below Photogenic fall fashion at Nanzen-ji.

Right Matte white makeup is a distinctive feature of the esoteric Gion *maiko*.

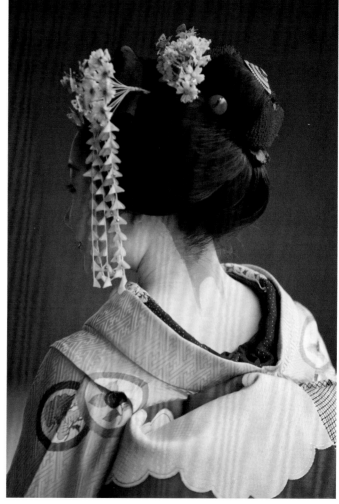

Left A mendicant monk wearing a *takuhatsugasa* hat of woven rice straw seeks alms.

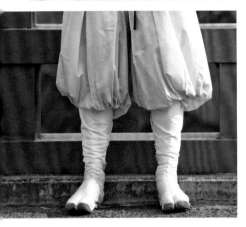

Left Bloused white trousers with matching *jikatabi* split-toe boots.

Left below A Zen monk's *zori* sandals.

Right A *maiko* in a classic kimono prepares *matcha* green tea against a backdrop of pale pink cherry blossoms.

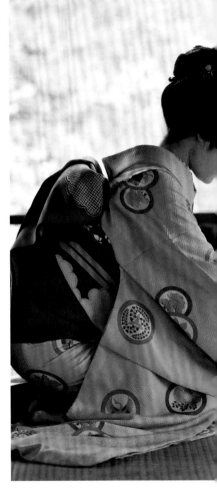

the job. The young man or woman in baggy jodhpur-like trousers and split-toe *jikatabi* boots, carrying large shears or other tools in a leather holster, is either headed for a gardening task or a construction site. Even the gravel used in many Kyoto gardens has a distinctive tone; it is *not* white but the subtlest of silvery grays.

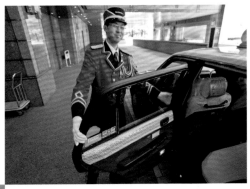

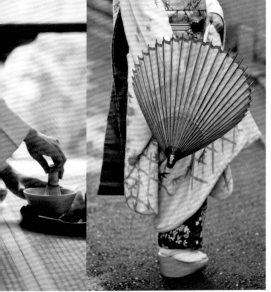

Above A jaunty hotel "footman" in white gloves, scarlet gold-trimmed tailcoat, and top hat.

Left A delicate silk *higasa* parasol for stylish protection from the sun.

Right An *ama* female monk in simple traditional robes.

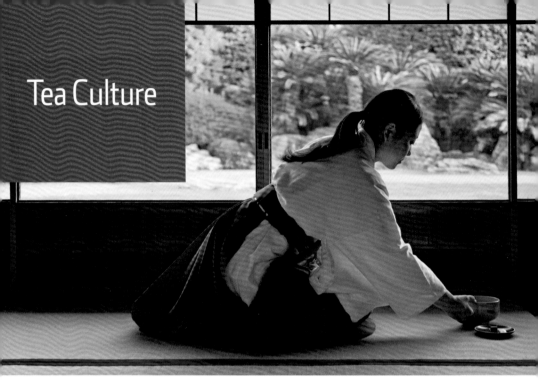

Tea Culture

Far left Stimulating and tasty *matcha* green tea served in an understated ceramic bowl.

Left A New Year's decoration composed of a simple pine sapling on the wooden gate of the Omotesenke School of Japanese Tea Ceremony.

Kyoto culture runs deep, with a rich historical heritage as well as the simple custom of doing even the most ordinary everyday things a particular way for hundreds of years. Kyoto culture has, in turn, deeply influenced the entire country. The Japanese art and culture of tea began in Kyoto. Japan's many schools of ikebana floral expressionism stem from the 15th-century Buddhist priest Senko Ikenobo in Kyoto, reverentially decorating his temple altar with flower arrangements inspired by his understanding of Buddhism. Kyoto Zen underpins both tea, with its rich cultural manifestations, and the city's unique temple gardens. Those Zen gardens, in turn, are reflected in the pristine riverbanks of the Kamogawa and in the very air of Kyoto, where the fragrance of incense permeates this city like no other.

Author and aesthetician Donald Richie posited traditional Kyoto culture as "tea tasting, flower viewing, moon gazing, incense smelling, poetry contests—the aesthetic pursuits." All of these cultural elements inherited from the ancient capital still reverberate with contemporary Kyotoites at an innate level in a most natural way, even as residents adapt to the inevitable changes of this century. Kyoto's new International

Manga Museum perhaps symbolizes a hopeful balance for the city's cultural future as modernity challenges the preservation of ancient customs. The beautiful renovation of an old unused elementary school in the center of Kyoto to invitingly sanctify the Japanese pop arts of *manga* and *anime* seems a rare stroke of genius, akin to the Musée d'Orsay art museum created from the former Orsay Railway Station in Paris.

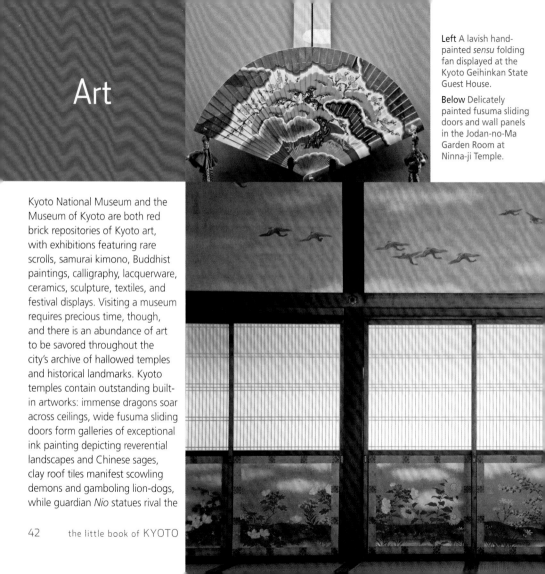

Art

Left A lavish hand-painted *sensu* folding fan displayed at the Kyoto Geihinkan State Guest House.

Below Delicately painted fusuma sliding doors and wall panels in the Jodan-no-Ma Garden Room at Ninna-ji Temple.

Kyoto National Museum and the Museum of Kyoto are both red brick repositories of Kyoto art, with exhibitions featuring rare scrolls, samurai kimono, Buddhist paintings, calligraphy, lacquerware, ceramics, sculpture, textiles, and festival displays. Visiting a museum requires precious time, though, and there is an abundance of art to be savored throughout the city's archive of hallowed temples and historical landmarks. Kyoto temples contain outstanding built-in artworks: immense dragons soar across ceilings, wide fusuma sliding doors form galleries of exceptional ink painting depicting reverential landscapes and Chinese sages, clay roof tiles manifest scowling demons and gamboling lion-dogs, while guardian *Nio* statues rival the

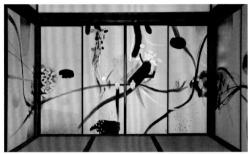

Above A beautiful bronze guardian lion sculpture at Kuramadera Temple.

Above An expressionist composition of painted fusuma panels at Honen-in Temple.

Below A delicate Chinese-style painting on cedar *mairado* doors at Kyoto Imperial Palace.

sculptural grace of Michelangelo's *David*, but with eyes to pierce the soul.

The lavishly decorated Karamon Gate at Nishi Hongan-ji, one of the temple's many National Treasures, is like a gallery of Kyoto art all by itself, popularly said to require all day to fully appreciate its intricately carved wooden transoms and colorful creatures. Nijo Castle, with its own spectacularly carved transoms and illustrated palace interiors, is more of an art exhibit than a martial stronghold. The glass teahouse, "Abode of Light," at Shoren-in

Bottom left A dramatic dragon mural rendered on fusuma doors at Kennin-ji.

Bottom right A dynamic wooden relief carving in the Hondo Hall of Nison-in Temple.

Below Tea pavilion with modernist accent in painted fusuma doors at the Mirei Shigemori Garden Museum.

Temple's mountaintop observatory is a striking example of temporary art installations to be discovered in Kyoto. The city's temple gardens are unique Kyoto artworks as well, whether experienced as sculptural masterpieces or two-dimensional compositions. The Mirei Shigemori Garden Museum is a memorial work of art dedicated to Shigemori, the 20th-century Kyoto artist who blended modern art and traditional garden tenets so superbly.

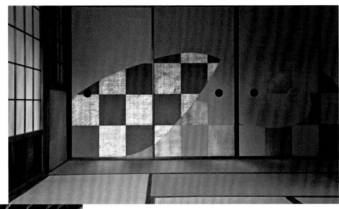

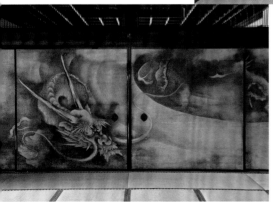

Above Ikebana displayed in a spartan *tokonoma* alcove at Manshu-in Temple.

Right A muted lotus study on a fusuma sliding door in the Meditation Hall at Okochi Sanso.

Kyotoites

The people of Kyoto share the immense artistic and historical treasures of their city with great generosity and patient forbearance. Kyoto residents justifiably take great pride in traditional trades and craftsmanship, with unmatched skills honed over generations in their epicenter of traditional Japanese culture. Considered by some uninformed few to be perhaps a bit *too* sophisticated or pretentious about their ancient capital's heritage, Kyotoites actually maintain an impressive humility and touching sense of gracious hospitality under the mounting pressures of tourism, achieving an essential symbiosis with the crowds in their midst.

Above In Kyoto, kimono are not just for special occasions.

Right A local resident in a pastel kimono is a natural at her neighborhood *machiya* restaurant.

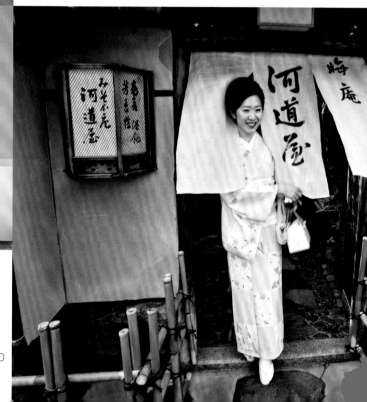

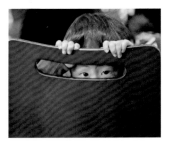

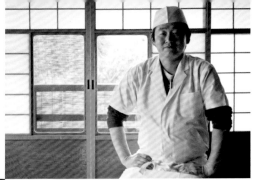

Far left A shy yet curious young Kyotoite at Kyoto Station.

Left A Kyoto chef exemplifies professional pride and competence.

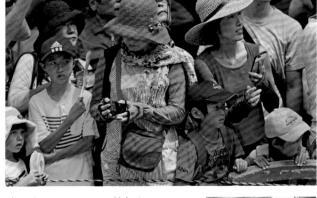

Above Even summer's debilitating heat does not discourage Kyoto fans of the annual Gion Festival.

Right A young digitally equipped Kyoto family aboard the Kintetsu Railway.

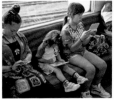

Serendipitous encounters with individual Kyotoites can make a fulfilling visit to their city even more memorable. A gardener from a Kyoto gardening family shared childhood stories of growing up there, of swimming in temple ponds and roaming through the now restricted mountain gardens that he considered his private playground. A young woman, meditating on the stone bridge by Nanzen-ji's lotus pond before opening her nearby teashop, confided that the delicate scent of the soft pink flowers was as calming as the early morning quiet. A kind

Below Even Zen monks sometimes need a break.

Right Diligent gardeners at Konchi-in Temple prune an *akamatsu* red pine, needle by needle.

Left High school baseball players take a short cut through the grounds of Myoshin-ji Temple.

Below A brief spring shower brings a sunny smile on the slope of Kiyomizuzaka.

older woman stopped a clueless visitor on his bicycle just to bestow a gift of beautifully wrapped sweets. A local gentleman stood alone at dusk in the silent forest at Kamigamo Shrine, perfectly still, eyes closed, hand over heart, soaking in the sweet power of that sacred place.

Right A modern Kyotoite outfitted from the ground up with Timberland boots and fine rims on his classic Monte Carlo.

KYOTO'S IMPERIAL LEGACY

Kyoto was Japan's imperial capital for more than a millennium, from 794 to 1868. Over those many centuries, the imperial court and its attendant culture created a rich tapestry of arts and architecture in Kyoto, continuously refining Asian imports such as Zen, tea, and calligraphy. The influence of strong-willed and highly educated Buddhist leaders, feudal clan warlords, and generations of shogunate dominance shaped the city's imperial legacy through wars, conflagrations, and repeated reconstruction cycles. The imperial city was to be irrevocably changed, though, in late 1867, when Japan's last shogun abdicated, ceremoniously relinquishing his ruling power to the emperor at Nijo Castle.

When the fateful decision was reached for the young emperor to depart Kyoto the following year and establish a new "Eastern Capital" in the former shogun's Edo stronghold, renamed Tokyo, the people of Kyoto were shocked and dispirited. But bitter disappointment could not overshadow a centuries-deep pride, and Kyoto's imperial endowment of palatial beauty and classical Japanese culture proved a resilient archive. Surviving even the Pacific War miraculously unscathed, Kyoto's historical treasures and imperial bonds constitute an essential heritage that remains the richest depository of Japanese culture anywhere in the country. Kyoto is eternally the *spiritual* capital of Japan. Recent loosening of restrictive protocol makes it easier than ever to savor the imperial properties of palaces and villa gardens in Kyoto, the ancient capital that was one of Japan's last forbidden realms.

The sixteen-petal imperial chrysanthemum motifs at Ninomaru Palace symbolize Nijo Castle's link to the imperial family.

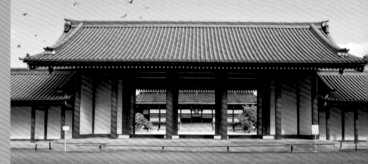

Kyoto's Imperial Palace

Rising phoenix-like from the ashes of repeated destruction by fires and warfare, the Kyoto Imperial Palace that survives today was largely re-built by the Tokugawa shogunate in 1855. Its imposing elegance reflects the once-divine imperial presence, yet the modernist eye of outspoken and influential 20th-century German architect Bruno Taut was impressed to find Kyoto's Imperial Palace "characterized also by simplicity and the greatest restraint in decoration. Its courts, corridors and all its rooms where the gorgeously clad followers stood about are remarkably simple."

A tall earthen wall around the Imperial Palace encloses restrained traditional gardens and massive halls with graceful cypress bark roofs. The

Top Jomeimon is one of three gates to the Dantei inner courtyard.

Left Beautifully grained doors with vermilion hardware at Giyoden Hall.

Right Hand-painted cedar *mairado* doors at Otsunegoten, the emperor's former residence.

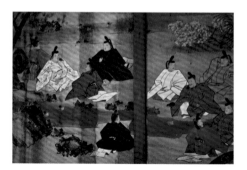

most important, the Shishinden, with its vast white sand courtyard, was the palace's ceremonial hall, further surrounded by a corridor with vermilion-hued columns and towering gates. The British Consul's historical first audience with the

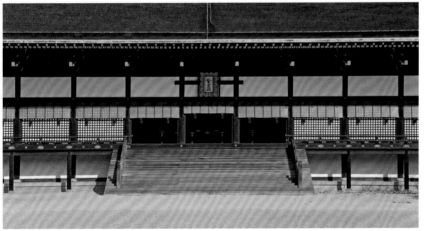

Above left An attendant and richly lacquered gateway door at Jomeimon.

Above A structurally sound and aesthetically pleasing array of cinnabar-lacquered wooden columns and roof supports.

Left The august Shishinden Ceremonial Hall is roofed with Japanese cypress bark.

emperor was to be held there on March 23, 1868, but was delayed by anti-foreign fanatics with razor-sharp swords who attacked the minister's retinue en route. Valiant samurai escorts prevailed, and the consul succeeded in meeting the emperor at the Shishinden on his second attempt. Later that year, the teenaged emperor departed Kyoto Imperial Palace in his black-lacquered palanquin for Tokyo, the new "Eastern Capital," ending more than a thousand years of Kyoto's reign as Japan's imperial capital.

Below An *aosagi* gray heron keeps an eye on the Oikeniwa Garden's pond from atop a stone lantern.

Right Kenreimon is the southernmost and main gate of Kyoto Imperial Palace.

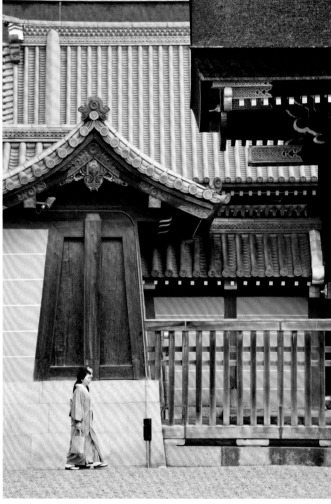

Left An ornamental *giboshi* finial on a wooden veranda railing at Otsunegoten Hall.

Right A gracefully arched earth-and-wood bridge in the Gonaitei Garden.

Below The Shodaibunoma Hall's Tiger Room was the waiting area for highest-ranked visiting dignitaries.

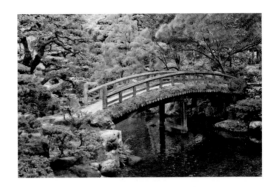

Sento Imperial Palace

Left Reflections of autumn perfection at the South Pond.

Below Wide shoe-removing stones facilitate entry to the Seikatei teahouse.

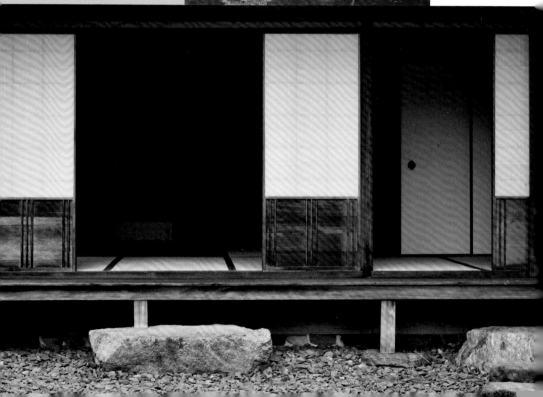

Below right An arched stone bridge in gardens originally designed by Kobori Enshu in 1630.

Right Elegant rooflines of the Okurumayose Entrance Hall.

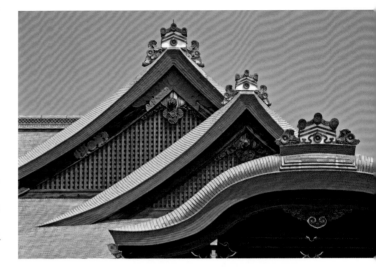

Located just a short walk from the Imperial Palace within the spacious grounds of Kyoto Gyoen National Park, the Sento Imperial Palace was originally built as the residence of retired Emperor Gomizuno in 1630. Repeated fires and reconstructions eventually left only the Seikatei and Yushintei teahouses and the exceptionally fine gardens within the earthen-walled enclosure. The elegantly roofed halls of the adjoining Kyoto Omiya Imperial Palace, built for the empress dowager in 1867, now serve as the visitors' entrance to Sento Imperial Palace, and accommodate the emperor on his imperial visits to Kyoto.

The excellent traditional strolling gardens that surround the North and South Ponds of Sento Imperial Palace are a visual and experiential delight in every season. Resident

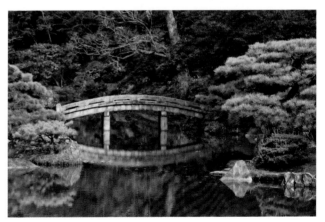

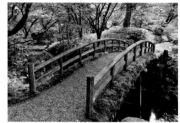

Left Thatch and bark roofs above a natural bamboo gutter at the Yushintei teahouse.

Above A gravel footpath crosses an earth-and-wood bridge at the North Pond.

Kyoto author, Judith Clancy, considers the Sento gardens "an aesthetic miracle of quietude, simplicity and beauty right in the middle of the city." Originally created by the renowned Edo-period artist and tea master Kobori Enshu (1579–1647), a walk through the gardens crosses a variety of graceful bridges, revealing rich vistas of wooded shoreline, waterfowl, and seasonal blossoms, before ultimately leading to the symbolic Suhama shore containing some 111,000 rounded stones, each carefully selected and skillfully placed.

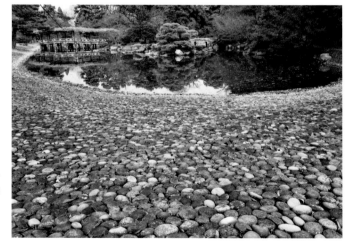

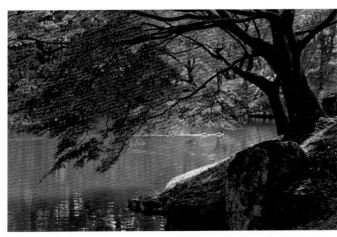

Left Scarlet maples and wild ducks at the North Pond.

Below A waterfall framed by autumn foliage flows into the South Pond.

Opposite below The South Pond's Suhama shore was created with an estimated 111,000 rounded stones.

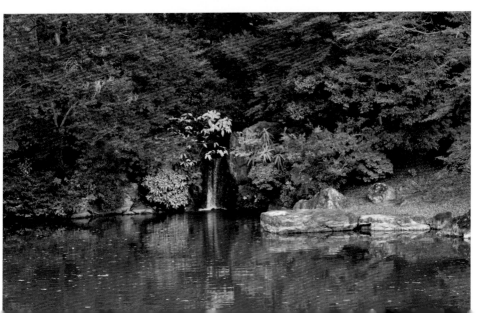

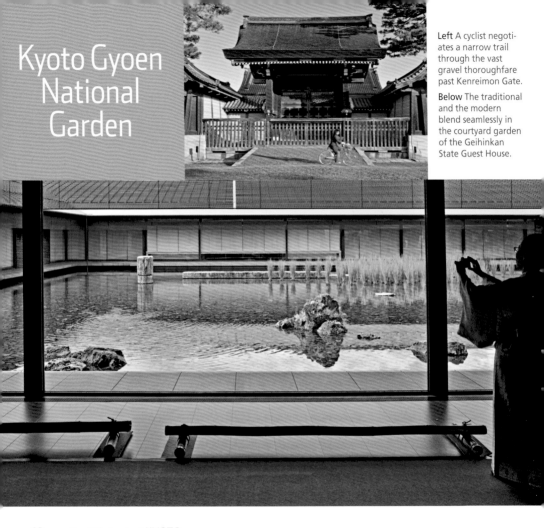

Kyoto Gyoen National Garden

Left A cyclist negotiates a narrow trail through the vast gravel thoroughfare past Kenreimon Gate.

Below The traditional and the modern blend seamlessly in the courtyard garden of the Geihinkan State Guest House.

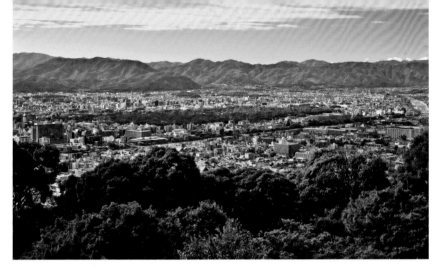

Viewed from a distant mountaintop perspective, Kyoto Gyoen National Garden appears as a vast green enclave in the heart of the great river valley basin of Kyoto. Stretching almost 1 mile (1.6 km) north to south, Kyoto Gyoen encompasses the Imperial and Sento Palaces as well as the Kyoto State Guest House (Kyoto Geihinkan). The spacious grounds also contain a children's park, forests, Shinto shrines, tennis courts, peach and cherry groves, and miles of wooded paths and wide gravel boulevards that are open to the public all year round.

Kyoto Gyoen National Garden is a popular spot for joggers, painters, and birdwatchers, for club meetings, picnics, and naps, and for relaxing with scenic mountains as a backdrop beyond the garden's greenery. The Geihinkan opened in 2005 but was accessible only by foreign VIP guests of the government. However, along with recently relaxed procedures for visiting all of Kyoto's imperial properties, visitors are now allowed (for a fee) to sample the rarefied air of the Kyoto State Guest House halls and contemplate the beautifully landscaped garden with its pond

strikingly incorporated into the architectural design of the complex. Yet only a VIP stands a chance of trying out the pond's wooden rowboat under a full moon.

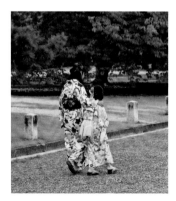

Left A mother and daughter in summer *yukata* stroll along a wide gravel boulevard.

Above A squad of Zen monks in indigo blue robes pass the northern Imadegawa boundary of Kyoto Gyoen.

Far left Ginkgo leaves brighten a rainy fall morning.

Left A wood-and-paper lamp made with traditional Kyoto joinery enhances a corridor at Kyoto Geihinkan.

Right A wooden *wasen* rowboat for VIP guests at the Kyoto Geihinkan.

Below *Suiren* water lilies and koi carp add splashes of color to the Geihinkan's garden pond.

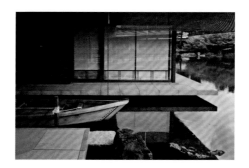

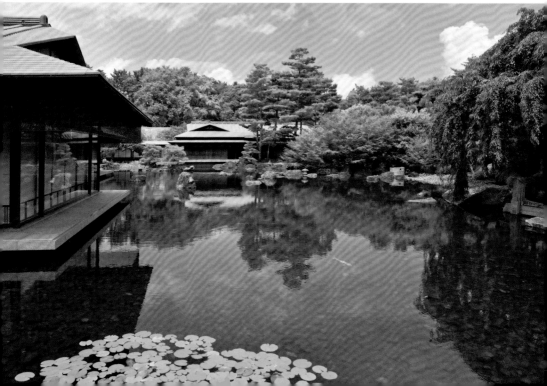

Nijo Castle

Left An inticately carved wooden *ranma* transom at Karamon Gate.

Below Ninomaru Goten Palace is a National Treasure and an architectural marvel, both inside and out.

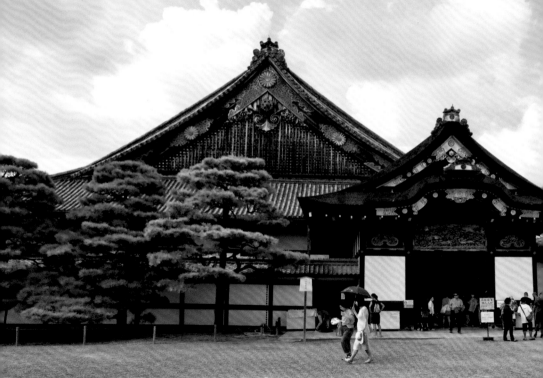

Nijo Castle, a World Heritage Site located just southwest of Kyoto Gyoen National Garden, is a flatland castle originally built in 1603 as the dominating symbolic residence of Shogun Ieyasu Tokugawa for whenever he visited the city. One of the first foreign visitors to see it, an observant British diplomat in 1868, Sir Ernest Satow, was not impressed: "The Tokugawa Castle of Nijo struck me as insignificant compared with many a fortress belonging to a small Fudai daimyo." Nijo Castle had been designed to project wealth and power commensurate with the rival Imperial Palace hierarchy, to protect the shogun's image more than as a strategic military fortress to protect the city of Kyoto.

Acting as de facto ruler while the nearby emperor served as token monarch, Ieyasu spared no expense with Nijo Castle, and incurred none, demanding his feudal lords in western Japan cover *all* the construction costs. With richly

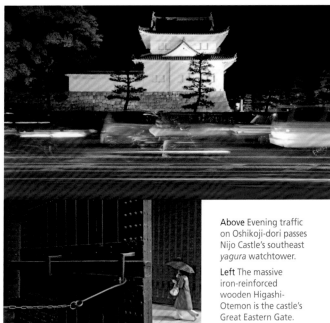

Above Evening traffic on Oshikoji-dori passes Nijo Castle's southeast *yagura* watchtower.

Left The massive iron-reinforced wooden Higashi-Otemon is the castle's Great Eastern Gate.

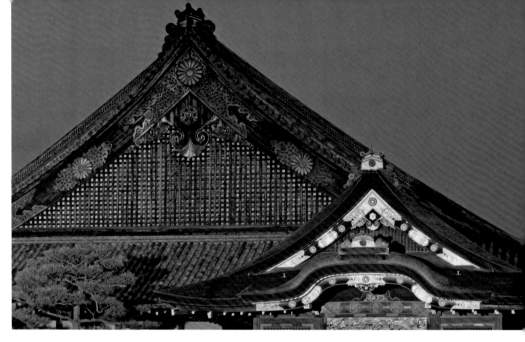

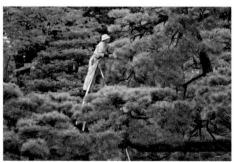

Right A gardener balanced on a tripod ladder tends a large pine tree in the Honmaru Garden.

detailed camphor wood gates and elaborate transom carvings fashioned by skilled craftsmen using a staggering variety of *nomi* chisels, the lavishly illustrated interiors of Nijo's Ninomaru Palace (now a National Treasure) are also famous for squeaky "nightingale floors" intended to discourage any ninja-like intruders. The shogunate engaged

the aesthetic tea master Kobori Enshu to create the Ninomaru Garden. Soon after the last shogun returned ruling authority to the emperor during a ceremony at Nijo in November 1867, and subsequently decamped, palace officials promptly began replacing the castle's Tokugawa hollyhock crests with imperial chrysanthemums.

Above A long storehouse with *kawara* tile roof flanks the inner moat below the castle's stone *donjon* keep.

Left Cherry trees and azaleas border a gravel footpath between the inner and outer moats.

Heian Jingu Shrine

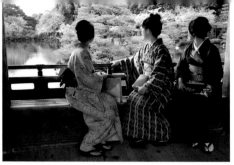

Left The Taiheikaku covered bridge in the Eastern Garden.

Below A vast sand courtyard leads to the Daigokuden, Heian Jingu's Great Audience Hall.

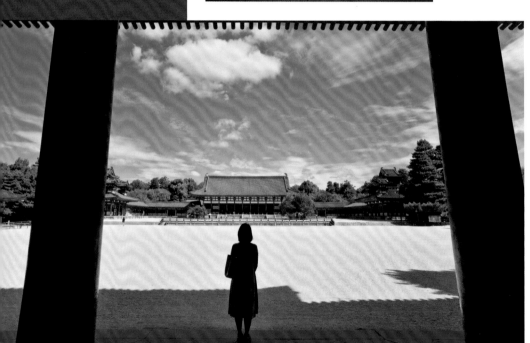

Heian Jingu Shrine is a conscious reflection of Kyoto's imperial legacy, built in 1895 to belatedly celebrate the city's initiation of imperial capitalhood. Constructed in the style of the Imperial Palace of the Heian Period (794–1185), Heian Jingu is dedicated to the first emperor, Kanmu, and to the last, Komei, to rule the country from Kyoto. The sacred shrine's towering vermilion torii gate is one of Japan's largest Shinto gates and is a revered Kyoto landmark.

The extensive gardens of Heian Jingu wrap around the outer shrine in classic strolling layout, created by Ogawa Jihei VII, the seventh generation of a distinguished Kyoto

Right A stone dragon fountain and *miko* shrine maidens.

Below Otenmon is the shrine's Divine Gate.

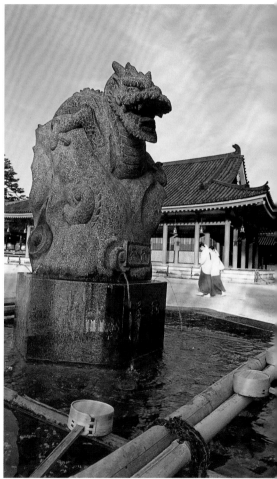

family of landscape architects, who labored on the shrine's gardens for twenty years. Author Judith Clancy admiringly suggests that Heian Jingu's gardens "might possibly be the most inviting place on earth in April when its hanging cherry trees envelop one's passage under their graceful blossom filled limbs." Certainly, the shrine gardens offer potential haiku material every day of every season. The kind woman tending the quiet tea pavilion by the "lying dragon" stepping-stone bridge, its somewhat precarious steps made of old cylindrical bridge pillars, says she has never actually seen anyone fall into the garden pond there, but has clearly heard the big splash when someone does occasionally slip off the dragon's back.

Below A *miko* shrine maiden and a traditional cloister.

Right The Soryu-ro "Blue Dragon Tower."

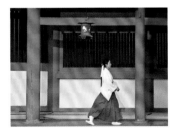

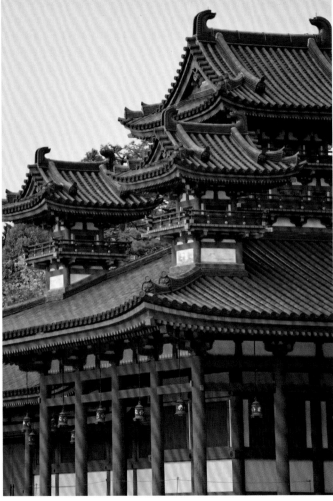

Above A *suiren* water lily in the West Garden's Soryu-ike Pond.

Below A skillfully sculpted *akamatsu* red pine beside Byakko-ike Pond.

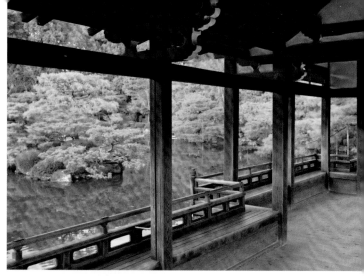

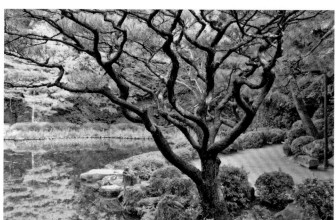

Above The wooden corridor bridge at Seiho-ike Pond in the Heian Jingu Garden.

Below Water lilies in the Nishi Shin-en Garden, designed by 19th-century landscape architect Ogawa Jihei VII.

Shugaku-in Imperial Villa

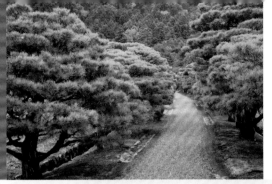

Left A strolling footpath bordered by pine trees was added during the Meiji era.

Below The shore of Yokuryuchi Pond reflects meticulous grooming.

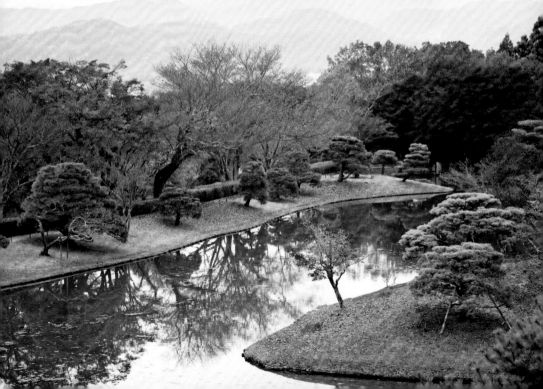

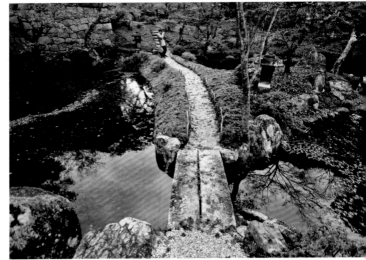

Right A simple stone bridge and narrow walkway lead to the Jugetsukan teahouse.

The vast grounds of the Shugaku-in Imperial Villa cover more than 130 acres (53 ha) in the foothills of the Higashiyama Mountains in the remote northeastern area of Kyoto. Productive vegetable gardens and rice fields co-exist below the three levels of formal gardens and teahouse villas that climb up the hillsides. The Japanese gardening technique of *shakkei*, using "borrowed scenery" to supplement a garden's backdrop, is evident in almost every direction at Shugaku-in, compositions continually emerging from the seemingly infinite arrangements that unfold while strolling and climbing along the artistic garden paths.

Shugaku-in was built as an imperial retreat between 1655 and 1659, at least in part to be far removed from shogunate political intrigue down in the central city districts of the capital. Gazing from a hilltop teahouse villa at Shugaku-in during a visit in the 1930s, the critical German architect Bruno Taut, the first Western eye to consider Japan's

Left A traditional wooden gate roofed with *kawara* ceramic tiles and sprinkled with autumn leaves.

Above A stone *toro* lantern and hillside steps below the Otaki Waterfalls.

traditional architecture from a modernist perspective, expounded: "Standing there in its clear beauty, this pavilion expressed such cleanliness and purity … the people in those ancient times must naturally have been animated by similar ideals." Contemplating the Shugakuin's villas of refined elegance nestled so comfortably amidst the carefully shaped garden landscape can also calm the modern soul, a timeless meditation that is still relevant.

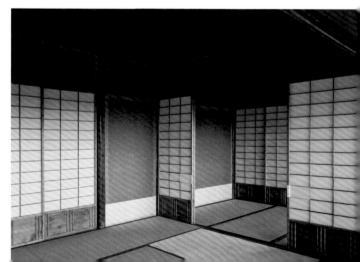

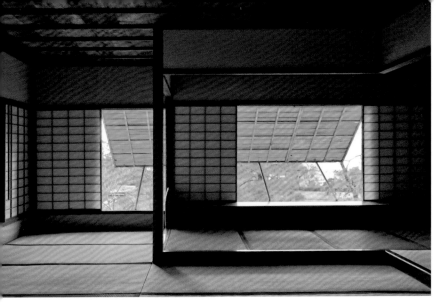

Left Refined elegance and simplicity revealed by natural light inside the Kyusuitei tea pavilion.

Below *Momiji* maple leaves cover thick moss and a curving gravel path.

Above A gardener in a conical rice straw hat whisks up fallen leaves.

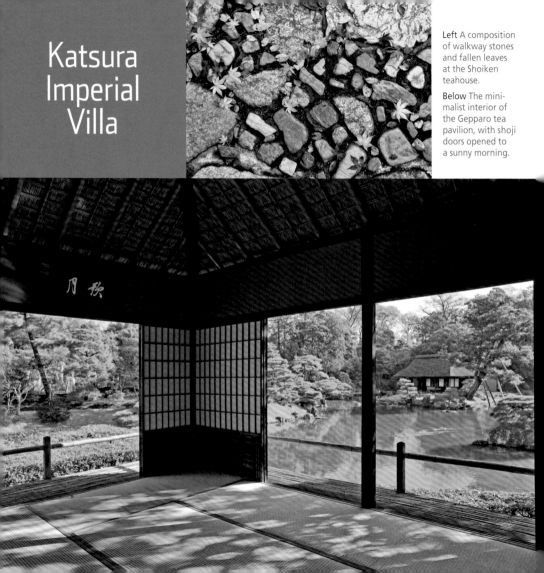

Katsura Imperial Villa

Left A composition of walkway stones and fallen leaves at the Shoiken teahouse.

Below The minimalist interior of the Gepparo tea pavilion, with shoji doors opened to a sunny morning.

Far left Miyukimon is a traditional wooden gate with a thatched gable roof.

Left Attendants and volunteers help with gardening chores.

Katsura Imperial Villa was constructed on the southern bank of the Katsura River in western Kyoto between 1589 and 1643, a retreat for generations of imperial princes devoted to the arts and literature. Zen philosophy and tea culture were incorporated with classical *sukiya* architectural style and garden landscaping design. The result is a masterpiece of timeless beauty, what the perceptive Bruno Taut declared to be "this greatest Japanese work of art." Katsura's beauty also lies in tiny details that are easy to overlook. Discovering delicate door pulls shaped like boat oars or duck-hunting arrows in a teahouse by the pond reveals the playful hearts as well as educated minds of those ancient princes and dedicated craftsmen.

Other modernist 20th-century architects, including Le Corbusier

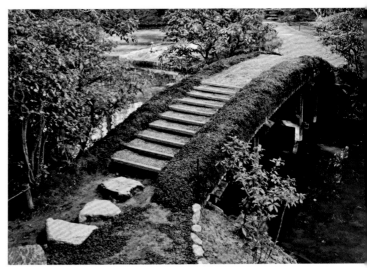

Above A gently arching earthen bridge connects islets in the garden pond.

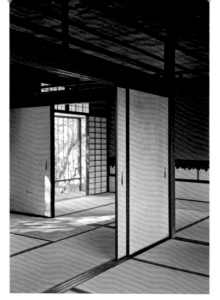

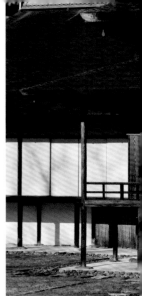

and the founder of Bauhaus, Walter Gropius, who made a pilgrimage to Katsura Rikyu in 1953, were influenced by this most refined of imperial retreats. The villa's seamless blending of architecture and garden also seems reflected in work by Frank Lloyd Wright, who certainly shared an appreciation of Japanese aesthetics. Considering the recently eased rules for visiting other Kyoto imperial properties, perhaps the somewhat long-winded expert guides at Katsura Imperial Villa will one day allow a free moment or two for contemporary visitors to savor their own impressions of this unique Kyoto treasure.

Above A round teahouse window of bamboo and vine lattice.

Above Sliding fusuma panels at the Shoiken tea pavilion are playfully fitted with oar-shaped door pulls.

Right The sedate and timeless interior of the Shokintei tea pavilion is arguably *the* perfect embodiment of Japanese aesthetics.

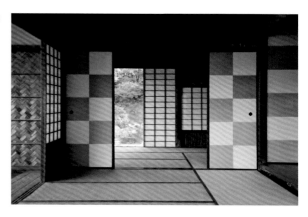

Left Elevated verandas and wide expanses of sliding *washi* paper door panels at the Shoin main building.

Below left The thatched Chumon Gate is also topped with moss.

Above Trees skillfully prepared for winter with *komomaki* protective straw wrappings.

Below The Shokintei tea pavilion contains a variety of apertures, including a low *nijiriguchi* "crawling-in entrance."

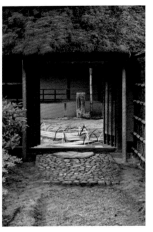

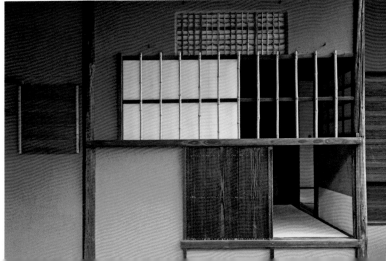

KYOTO HIGHLIGHTS

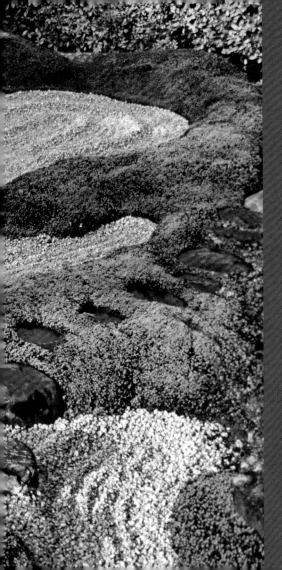

In a cultural treasure chest like Kyoto, which boasts seventeen UNESCO World Heritage Sites and hundreds of National Treasures and Important Cultural Properties, it is a wonderful challenge to plot a course of exploration. Among its thousands of Buddhist temples and Shinto shrines, certain Kyoto highlights demand a closer look and the chance for deeper contemplation. From Ryoan-ji, perhaps the world's most famous Zen temple, to Kamigamo Shrine, one of Kyoto's most sacred sites, the city's gems warrant as much time as can be spared when considering the ancient capital's uniquely rich mosaic.

The Zen Buddhist temple complex of Daitoku-ji offers a staggering abundance of refined art, inspiring architecture, minimalist gardens, and innate spirituality. The warm other-worldly glow of Kinkaku-ji's legendary Golden Pavilion is inspiring enough to overcome even the distracting abundance of selfie-seekers intent on proving they were there, though one may need to recover afterwards in the blessedly quiet temple gardens of nearby Toji-in. Venture further southward to experience the purity and perfection of Kyoto's oldest wooden pagoda at Daigo-ji, constructed with uncanny skill centuries before Columbus sailed for the New World, and to step through the vermilion tunnels of sacred Shinto gates on Mount Inari.

The Zen garden at Daitoku-ji's Zuiho-in Temple receives careful daily attention to maintain its naturalistic and symbolic perfection.

Kiyomizu Temple

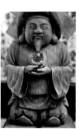

Left A *chozubachi* stone basin for ritual purification.

Left The Hondo Hall's magnificent wooden veranda stands fast without a single nail.

Below A rare *Daikoku-sama* god of fortune with a crystal ball for hands-on entreaties.

Right Reporting in after climbing above Romon Tower Gate.

Below Prayers at Zuigu-do Hall.

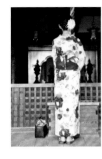

Kiyomizu-dera, the "Temple of Pure Water," perched on imposing ridges of Mount Otowa in Kyoto's eastern Higashiyama range, is a spectacular structure, an enduring symbol of the city's spiritual hierarchy. The namesake crystal-clear flow of pure mountain spring water gushes from the mountainside "Sound of Feathers" waterfall in three silent streams that can be sampled with long-handled cups to quench the perpetual thirst for health, longevity, and wisdom. A great stage-like wooden veranda juts out from Kiyomizu's Hondo Hall on an imposingly sturdy network of tall interlocking pillars and beams, ingeniously fashioned with nail-less precision. This veritable miracle of Japanese carpentry provides a sweeping panorama of the city, or a bird's-eye view straight down on cherry and maple trees in the temple's forested garden valley below.

Appearing often in Japanese literature and cinema, Kiyomizu-dera was originally founded in the 8th century and is now a World Heritage Site included in the Historic Monuments of Ancient Kyoto. The approach to Kiyomizu leads up a steep slope lined with busy shops

Above An attendant dusts the black-lacquered wooden *shitomido* latticed shutters of Kaizan-do Hall.

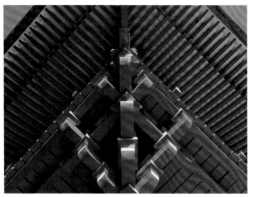

Right A touchable bronze Kannon, deity of mercy and compassion.

Center right A single candle at the center of worshipers' incense.

Far right A Bussokuseki stone symbolizes the Buddha's imprint.

Right below The freshly lacquered Koyasu Pagoda overlooks Kiyomizu's forested valley.

that create a festival atmosphere, a noisy procession until suddenly the temple's dramatic Niomon Gate and vermilion-lacquered pagoda can be glimpsed above. Climbing further,

author Donald Richie was awed by Kiyomizu-dera's massive temple halls, where "the great cypress-shingled roofs are continuations of the cryptomeria-covered hills."

Above The "Sound of Feathers" waterfall confers health, longevity, and wisdom.

Top left Elaborate brackets support the roof eaves of the Romon Tower Gate.

Right Visiting Kiyomizu-dera is a centuries-old ritual.

Far right An impeccably clad monk pays his humble respects.

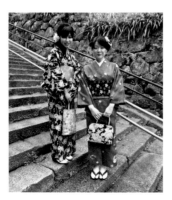

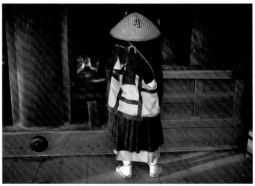

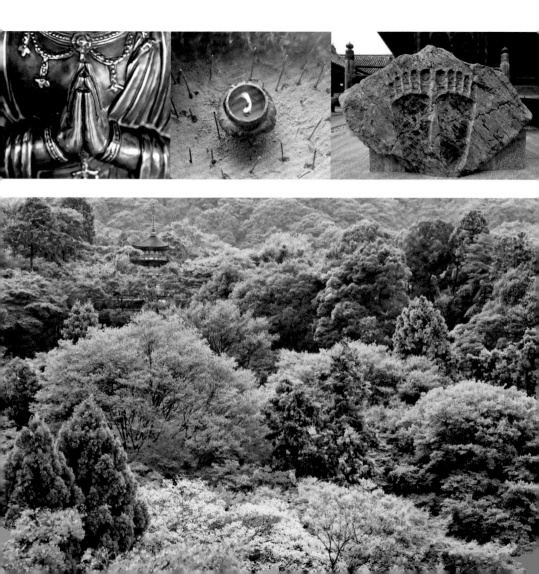

Shoren-in Temple

Giant 800-year-old camphor trees, which grace the hillside temple's outer grounds and tower above a quiet stretch of Jingu-michi "Shrine Road," are the first indication that Shoren-in might be something very special. Yet this 13th-century Buddhist temple of imperial lineage is often overlooked in a neighborhood close to other, more famous landmarks. Within the thick earthen-walled compound of Shoren-in are beautiful gardens created by the aesthete tea masters Soami (1472–1525) and Enshu Kobori (1579–1647). The gardens are a landscaped divinity flowing naturally around spacious temple halls connected by covered corridors. Shoren-in's atmosphere is peacefully solemn,

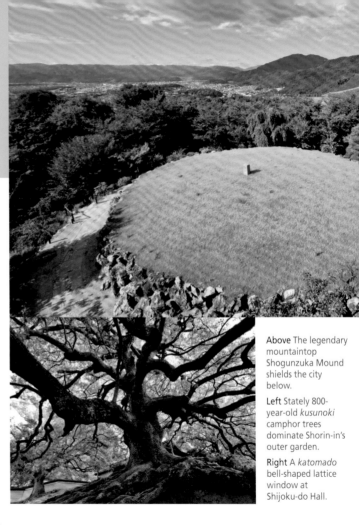

Above The legendary mountaintop Shogunzuka Mound shields the city below.

Left Stately 800-year-old *kusunoki* camphor trees dominate Shorin-in's outer garden.

Right A *katomado* bell-shaped lattice window at Shijoku-do Hall.

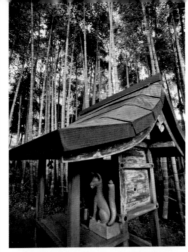

Left Hiyoshi Shrine sits atop the temple's hillside bamboo grove.

Below Afternoon sun illuminates the Shin-den Hall's spacious interior.

but pleasantly welcoming and blissfully relaxed.

Built along the foot of Higashiyama's Mount Awata, Shoren-in's temple property also includes the mountaintop, with pavilions, a spacious wooden viewing platform, and Shogunzuka Mound. The vast open-air observation deck is Kyoto's largest veranda and overlooks the

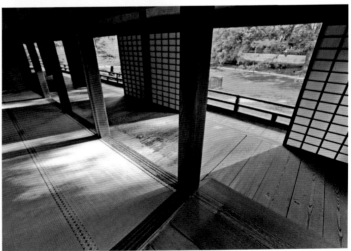

distant course of the Kamogawa River and the great green expanse of Kyoto Gyoen National Garden at the heart of the city. The historic Shogunzuka is where Emperor Kanmu is said to have stood atop the mound, gazing down upon the verdant valley basin below, surrounded by mountains to the west, north, and east, and envisioned his new imperial capital in 794.

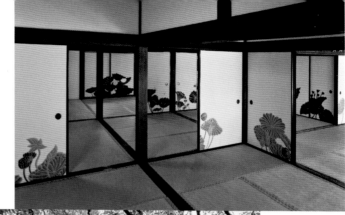

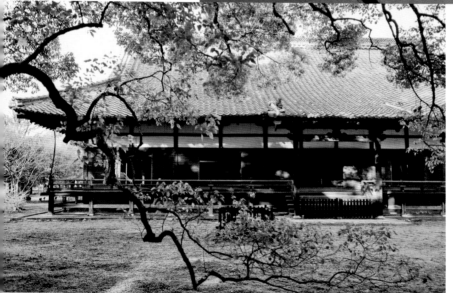

Above A veritable gallery of painted fusuma sliding doors inside Kacho-den Hall.

Left A moss carpet in the south garden by Shin-den Hall.

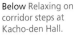

Below Relaxing on corridor steps at Kacho-den Hall.

Bottom left The bronze bell in the temple's garden belfry.

Bottom right The garden at Shogunzuka Dainichi-do was designed by eminent Kyoto gardening scholar Kinsaku Nakane.

Above Modern gardening techniques for an ancient camphor tree.

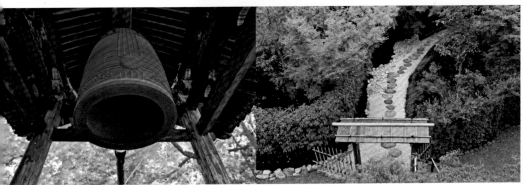

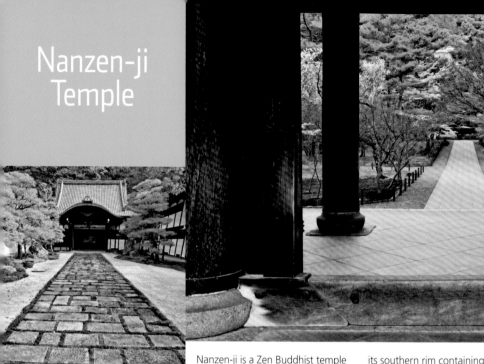

Nanzen-ji Temple

Above A path of stone and moss leads to the Hojo Hall.

Above right A vast spring courtyard separates Sanmon Gate and the Hatto Dharma Hall.

Nanzen-ji is a Zen Buddhist temple complex that extends up wide foothills in Kyoto's Eastern Mountains, seeming to grow right out of the local neighborhoods with no restrictive outer boundary. From its lowermost lotus ponds, Nanzen-ji's grounds gently slope up through the majestic three-story Sanmon Gate, with venerable temple compounds along its southern rim containing exquisite examples of Japanese gardening. An eloquent authority, writer Donald Richie found Nanzen-ji to be "like a mandala spread out on the slopes of Higashiyama."

Established in 1291, Nanzen-ji began as the villa of a retired emperor, an origin similar to many of Kyoto's finest temples. If so

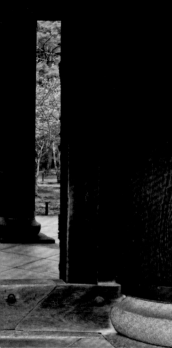

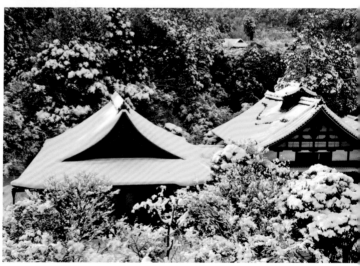

Left A stone bridge at Nanzen-in's Sogenchi Pond.

Below left The magnificent Sanmon Gate was built in 1628.

Below Snow accentuates the shapely roofs of the Hondo and Kiri Halls at Tenju-an Temple.

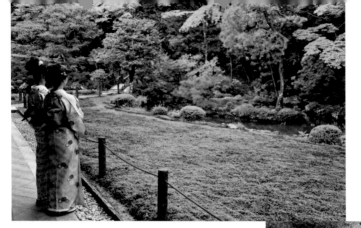

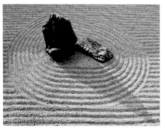

Above Garden reverie at Nanzen-in.

Left A sundial moment in the Hojo rock garden.

Above right A curvaceously fissured rock in the garden at Seiryoden Hojo Hall.

inclined, Nanzen-ji, with its remark-able concentration of beauty and spiritual heritage, seems a worthy candidate for World Heritage status in any future balloting. In the autumn, Nanzen-ji's woodlands and manicured gardens burst into an especially astounding palette of reds and golds. Nanzen-ji draws appreciative visitors and thoughtful pilgrims

Above A single pine adds contrast to autumnal tones in Tenju-an's Eastern Garden.

Opposite above An elegant visitor at the Hojo Garden, designed in 1600 by the artistic tea master Kobori Enshu.

Right Delightful covered corridors at Seiryoden Hojo Hall, a National Treasure dating to the 17th century.

from the southern end of the Philosopher's Path in every season. Crystalline water provides a soothing soundtrack, and tempts younger visitors searching for crayfish and other elusive creatures. The juxtaposed brick expanse of the elevated Suirokaku Aqueduct, part of the vital Lake Biwa Canal, creates a dynamic courtyard sculpture in the otherwise restrained Zen ambience at Nanzen-ji.

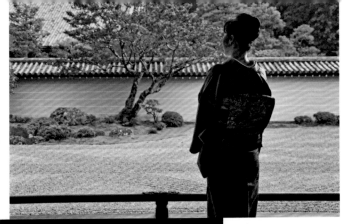

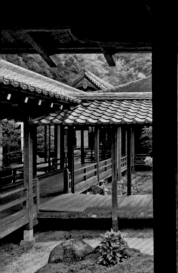

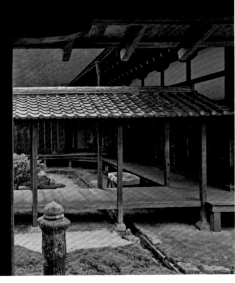

Above An ascetic *tokonoma* alcove with a *kakejiku* hanging scroll and a glazed clay censer in the Shoin Zen Study.

Daitoku-ji Temple

The extensive Zen Buddhist temple complex of Daitoku-ji, which covers more than 50 acres (20 ha) in north-central Kyoto, began as a small monastery in the early 14th century. With seminal ties to major figures in Buddhist art, literature, and the tea ceremony, such as tea master Sen no Rikyu, Daitoku-ji is richly infused with history and many rare gardens.

Of the numerous sub-temples within Daitoku-ji's walled compound, only a few are regularly accessible to visitors, but nonetheless offer more opportunity for the serious study or practise of Zen contemplation than can be found in *all* of Tokyo. Visitors might want to approach this finest of Zen enclaves with a clear mind and no other plans for the day.

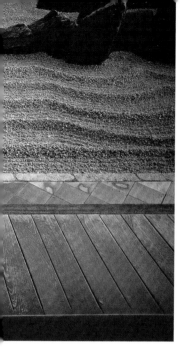

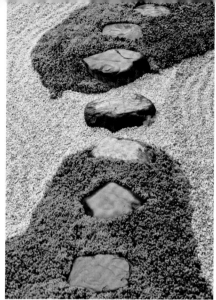

Left A perfectionist's garden path at Zuiho-in.

Below Shared quietude at Koto-in.

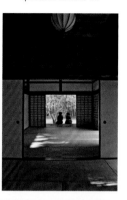

Above Zen monk, Zen garden.

Opposite Koto-in's restrained entryway hints at the wonders within.

Right A moss isle in a turbulent sea of gravel at Ryogen-in.

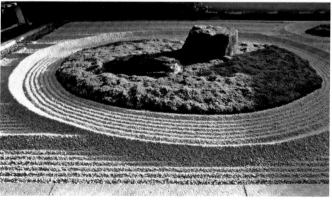

Established in 1601, Koto-in, a subsidiary temple within the main precincts at Daitoku-ji, stands out among all of Kyoto's innumerable temples for its divine restraint, forgiving and human. With a distinct lack of excessive rules, few tacky warning signs or squawking soundtracks, and the kindest of unobtrusive attendants, Koto-in remains a pristine and somber Zen temple that is truly refreshing and increasingly rare. Especially known for its long, narrow entrance walkway of artfully composed stone bordered with low bamboo fencing, Koto-in's interior gardens are uniquely subtle, with expanses of delicate moss amidst graceful Japanese maple trees, and perhaps even a weed or two.

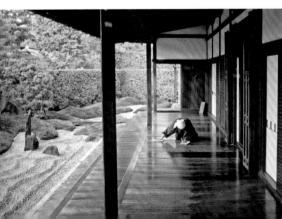

Far left Quotidian cleaning chores are an essential part of the meditative life.

Left A washbasin in Koto-in's garden, said to be fashioned from a cornerstone of the Korean Imperial Palace.

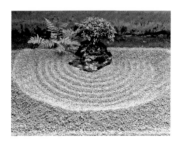

Left A red carpet for sitting beside Koto-in's autumn garden.

Above The simple rock-and-gravel Totekiko at Ryogen-in is purportedly Japan's smallest Zen garden.

Left Ebbing waves of gravel created with a precise rake.

Right The Shokoken teahouse at Koto-in was completed in 1628.

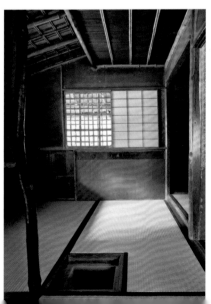

Kamigamo Shrine

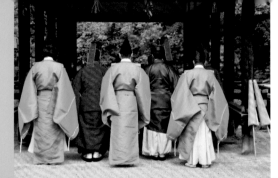

Left *Kannushi* priests conduct a ceremony at the Hashidono Pavilion Bridge.

Below Symbolic *tatezuna* sand cones at the Hosodono Haiden Hall.

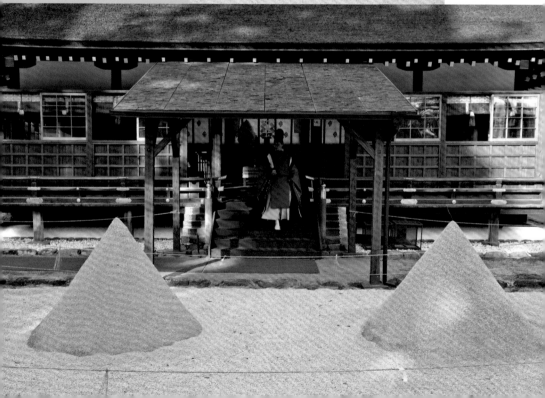

Kamigamo Jinja, a sacred Shinto shrine that is now a World Heritage Site, was originally founded on the eastern bank of the Kamogawa River at the foot of Mount Ko in the 7th century, even before Kyoto became the imperial capital. Kamigamo Shrine's forested grounds and clear flowing streams create a sanctuary of spiritual purity and seasonal beauty. The shrine pavilions, gates, bridges, and ceremonial halls are outstanding examples of refined traditional architecture. The historical Aoi Matsuri festival procession of imperial messenger, oxcarts, horses, and attendants in Heian-era apparel culminates at Kamigamo Shrine each year on May 15th.

No matter the weather or season, Kamigamo Shrine's spiritual atmosphere is potent and inspiring, and often holds a special surprise in

Above left A cascade of pure water at the *temizuya* is for ritual ablution.

Above The Nino Torii Gate of the inner shrine.

store for the observant visitor. One might glimpse a sacred white horse messenger being bridled or a Shinto wedding ceremony conducted just beyond the symbolic conical silvery-white sand *tatezuna*, each precisely sculpted and topped with a single pine needle. Misty rain blowing down from the mountain may

Above A young visitor arrives to celebrate Shichi-Go-San, a rite of passage for 7-, 5-, and 3-year-old children.

disperse the still reflection of a new bride's pure white kimono in the crystal clear Myojin River as *kannushi* priests emerge with large oilpaper *bangasa* umbrellas held above their colorful silk ceremonial robes and black-lacquered wooden *asagutsu* shoes.

Right A still life of ferns and maple leaves along the narrow Nara River.

Below A covered bridge over Omonoi Stream leads to the Honden Hall.

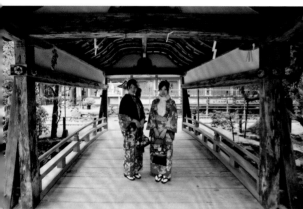

Left Paper lanterns with a lotus design placed in the shrine's sandy courtyard at twilight.

Right The West Torii Gate leads to the Shamusho Shrine Office.

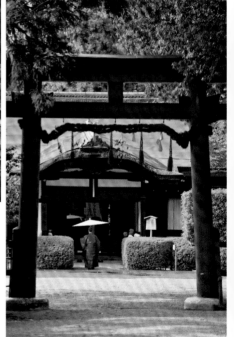

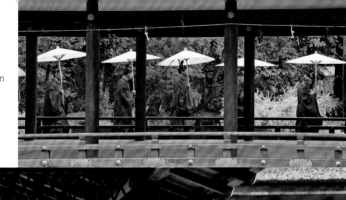

Below The sacred Honden, Kami-gamo's Main Sanctuary Hall, is a National Treasure.

Right A procession of Shinto priests with sturdy oil-paper *bangasa* umbrellas.

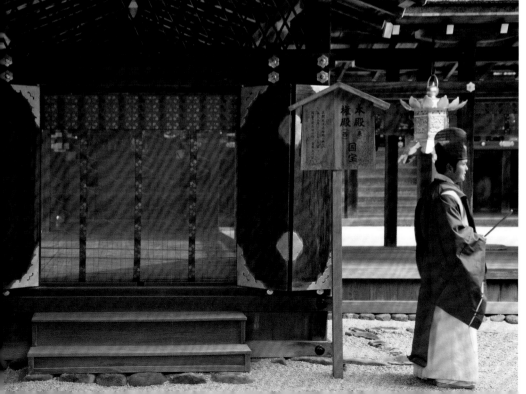

Kinkaku-ji Temple

Left A geometric window with bamboo lattice at the Sekkatei teahouse.

Below Snow on the Golden Pavilion is a rare pictorial blessing.

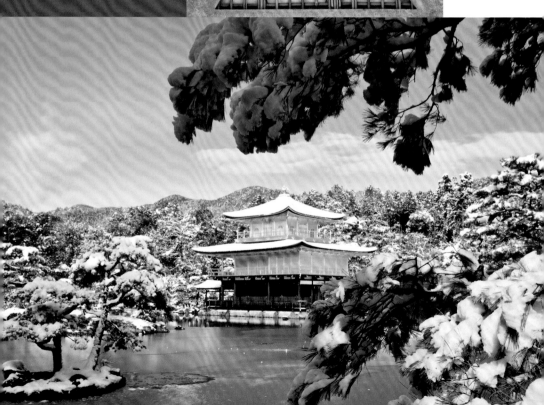

Below A sculpted stone *chozubachi* basin at the temple's teahouse for visitors.

Kinkaku-ji, renowned for its Golden Pavilion, was originally an aristocrat's estate that was expanded by Shogun Yoshimitsu Ashikaga as a retirement villa in 1397. Converted into a Zen Buddhist temple after his death, Kinkaku-ji is now a World Heritage Site and perhaps Kyoto's most famous landmark. Increasingly large numbers of admirers trooping through the temple's traditional gate can resemble a theme park entrance at times, but once inside the spacious earthen-walled compound, Kinkaku-ji's extensive and beautifully landscaped gardens do offer room to breathe. Mount Kinugasa provides an expansive natural backdrop of classic *shakkei* "borrowed scenery," enhancing the sense of spaciousness.

The upper two stories of the Golden Pavilion, a storehouse for sacred relics, are covered with pure gold leaf. The elegant structure reflecting in Kyokochi Pond is a glowing wonder in afternoon sunlight, like molten gold mixed with the mesmerizing colors of a campfire. Drawing steady streams of visitors even under drab or rainy skies, a rare snowfall accentuates the pavilion's

Top The upper stories of the Golden Pavilion are richly gilded with gold leaf.

Above The temple's Somon Main Gate is draped by *momiji* maple trees.

smoldering incandescence enough to cause a photographic frenzy at Kinkaku-ji. The temple's chronology is also attracting growing attention after the recent excavation of a gilt bronze fragment near Kinkaku-ji's tour bus parking lot. Archeologists hope the discovery may prove the existence of the shogun's legendary pagoda, Kitayamaoto, hypothesized to have towered over 328 feet (100 meters) as the tallest wooden structure in Japan's history.

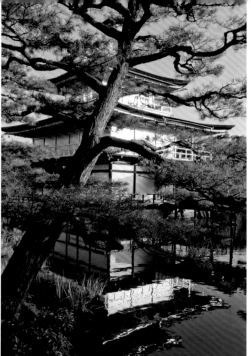

Far left "It's me at Kinkaku-ji!"

Left The Golden Pavilion shines through an artfully trimmed red pine.

Below left Sacred Ryumon Waterfall splashes upon Carp Rock.

Below right An idyllic pine island in Kyokochi Pond.

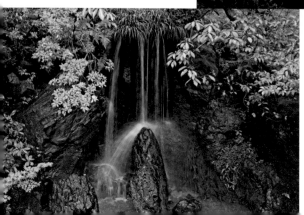

Below A patient gray heron fishes from an islet in Mirror Pond.

Right A pair of graceful flying cormorants complete a winter composition.

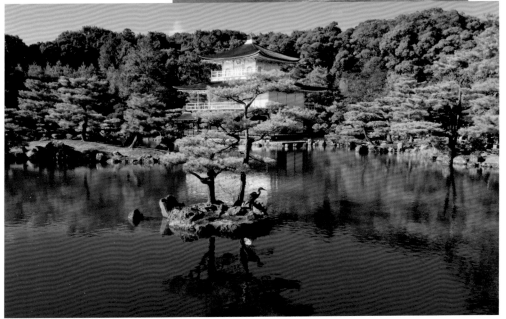

Ryoan-ji Temple

The rock garden at Ryoan-ji Temple is arguably the most famous Zen garden in the world. An 82 ft (25 m) by 33 ft (10 m) rectangular walled enclosure in front of the Abbot's Hall, Ryoan-ji's garden contains fifteen stones set in silvery-white Shirakawa gravel, kept carefully raked by acolyte monks. The richly patterned earthen wall, made of clay boiled in oil and topped with cypress bark and ceramic tile, serves to pictorially frame the abstract arrangement of garden elements. The immutably simple garden, a Zen enigma, is viewed from an unpaint-

Above A coin-shaped stone water basin at the Abbot's Chamber.

Right Raking the garden without leaving a trace is a Zen koan all its own.

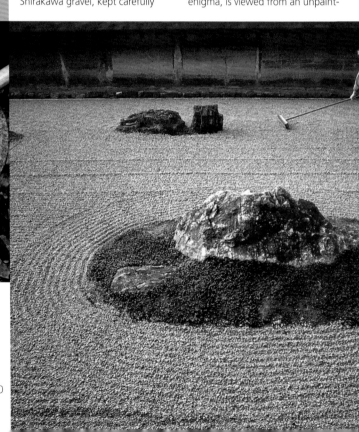

ed, unadorned wooden veranda. Frequently returning to Ryoan-ji during his lifetime, essayist Donald Richie admired the garden's humble nature and continuity, "Hidden away in a corner of a temple off in the suburbs of a city, it has the value of a whisper in a world of shouts."

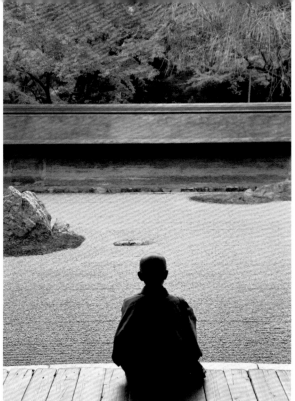

Now a World Heritage Site, Ryoan-ji began as a Zen training temple in 1450, located on a country estate in the foothills of Kyoto's northern Kitayama Mountains. The temple grounds also

Above A visiting monk motionless on the Hojo Hall's veranda.

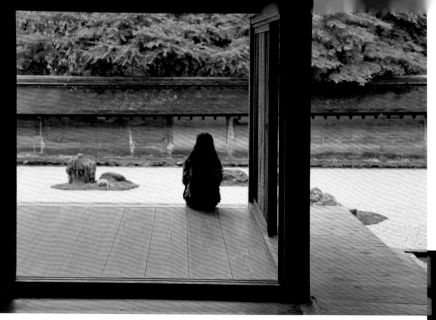

Left Savoring the garden's morning calm.

Below left A phalanx of busy gardeners.

include spacious strolling gardens conducive to quiet ruminations around Kyoyochi Pond, where a simple arched stone bridge leads to a small shrine on Bentenjima Islet. The spring-fed pond, centuries older than the renowned Zen rock garden, reflects the changing seasons of the wooded shore and surrounding hills on its placid surface, the ephemeral compositions dissolving and re-forming with the slightest breeze.

石庭拝観
ROCK GARDEN
入口
ENTRANCE

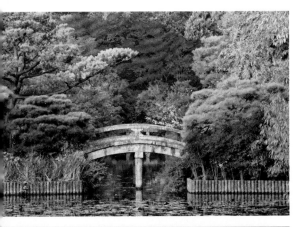

Left An arched stone bridge leads to a small shrine on Bentenjima Islet in Kyoyochi Pond.

Right Snow softens the rock garden's already minimal features.

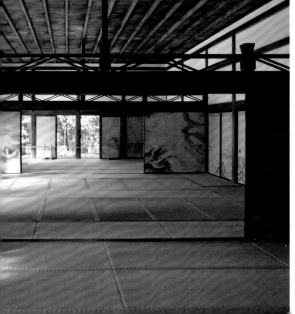

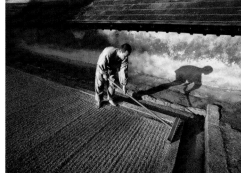

Left A succession of fusuma sliding partition ink paintings is the only decorative feature inside the Hojo Hall.

Above Morning sunlight casts a monk's shadow on the garden wall, an aesthetic boundary built of clay boiled in oil.

Toji-in Temple

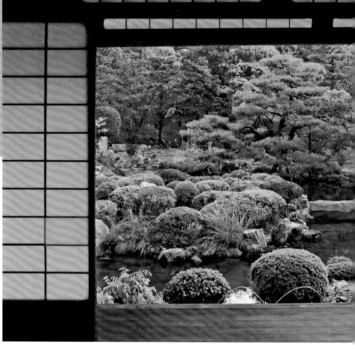

Located in a maze of quiet streets just south of the more besieged byways at Ryoan-ji and Kinkaku-ji Temples, Toji-in Temple offers a relaxing interlude from disruptive noise and flag-waving tour groups. *Matcha* green tea with a seasonal *wagashi* sweet can be savored in the *shoin*-style study while admiring the classic garden originally designed by the Zen master Muso Soseki (1275–1351). Slippers are used for stepping down and *into* the garden for a closer look at the thatched Seirentei teahouse and to experience the changing perspectives and vistas while exploring the circuitous paths linking two ponds in the beautifully landscaped grounds. The far

Shinji-ike Pond is secluded enough to attract an occasional heron.

Takauji Ashikaga, the first Ashikaga shogun, completed Toji-in, a Rinzai Zen Buddhist temple, in 1341. The temple halls are connected by covered wooden walkways that create a gallery for some of the temple's artistic holdings, including a large graphic painting

Left Autumn in the Fuyo-chi Garden, designed by gifted Zen priest Muso Soseki in the 14th century.

Below left Tea is served in the Shoin Study.

Right An ephemeral branch of crimson *momiji* maple leaves.

Below A *tsuitate* standing screen painting depicts the legendary monk Daruma, the original purveyor of Zen tenets from India to China.

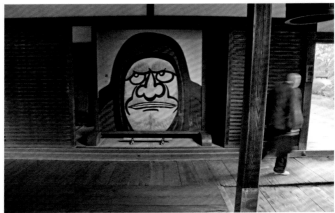

Far left Smooth wooden verandas connect the temple halls.

Left A simple *tsukubai* composed of a round stone basin with bamboo spigot and ladle at the Seirentei teahouse.

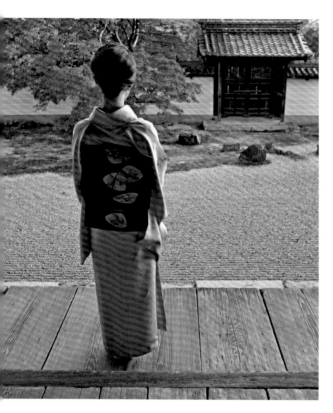

of Daruma, the legendary monk credited with conveying the tenets of Zen from India to China. The elevated verandas of unpainted planks at Toji-in also provide pleasing views of the stroll garden, with its lotus-shaped pond filled with clouds. The subdued *karesansui* "dry landscape" garden located in front of the Abbot's Hall is naturally conducive to a meditative pause.

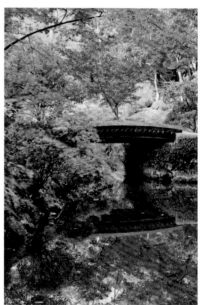

Above The Hondo Hall's *karesansui* dry landscape garden.

Right An earth-and-log bridge leads to an islet in Shinji Pond.

Far right The thatched Seirentei teahouse overlooks the temple's manicured Fuyo-chi Garden.

Right Afternoon sunlight reveals the work of virtuoso carpenters in the architectural elements of the entry hall.

Far right A gracious attendant serves *matcha* green tea by the garden.

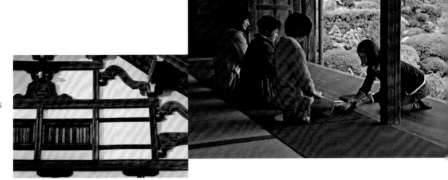

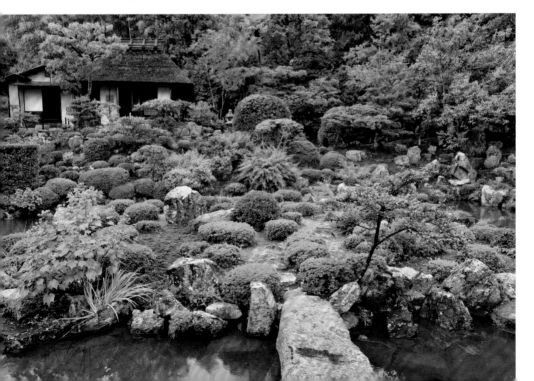

Daikaku-ji Temple

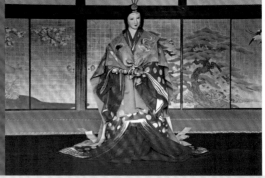

Left A special display of imperial court costumes at the Shinden Hall.

Below Daikaku-ji's Osawa-ike is said to be the oldest constructed garden pond in Japan.

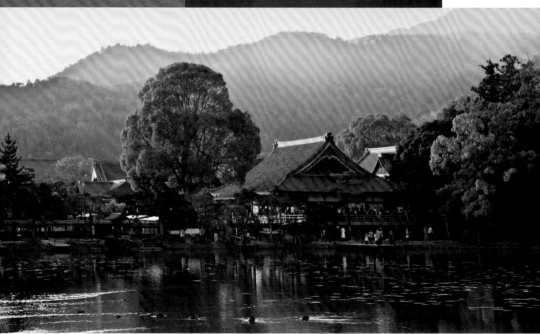

Daikaku-ji, one of Kyoto's oldest temples, was originally the imperial villa of Emperor Saga (786–842), a skilled calligrapher with deep cultural interests and said to have been the first emperor to imbibe tea. It was designated a temple by imperial decree in 876, honoring the founder of Shingon Buddhism, Kobo Daishi (774–835), as the Temple of Great Enlightenment. Its spacious grounds and remote location in the Sagano district of far western Kyoto still grace ancient Daikaku-ji with fresh countryside air and expansive sky above distant mountain views. The temple's Reihoukan Museum exhibits its rare historical art masterpieces.

Daikaku-ji's many temple halls of palatial architectural perfection are connected by an intricate network of covered wooden corridors with low ceilings intended to inhibit swordplay and *uguisu-bari* "nightingale floors" for discouraging stealthy intruders. A large wooden veranda at Godaido, Daikaku-ji's main hall where sutras are still transcribed each day, overlooks

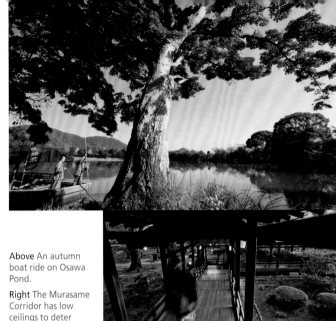

Above An autumn boat ride on Osawa Pond.

Right The Murasame Corridor has low ceilings to deter swordplay and squeaky "nightingale floors" to discourage intruders.

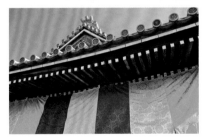

Right Festive *noren* curtains hang beneath the eaves of a *kawara* ceramic tile roof.

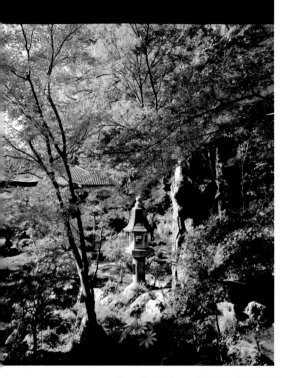

Emperor Saga's Osawa Pond, the oldest man-made garden pond in Japan, with its tiny Chrysanthemum Island and abundant waterfowl. The centuries have naturally integrated Daikaku-ji's garden landscapes with the surrounding *satoyama* hills and mountain background, never more so than under a full Harvest moon, when one might imagine elegant courtiers afloat on a moon-viewing soirée.

Below Tea attendants in matching kimono.

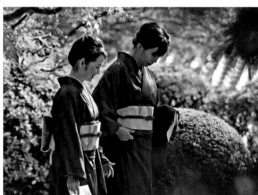

Above Peak fall colors in the courtyard garden at Reimeden Hall.

Left Green tea and seasonal sweets served on the veranda of the Godai-do Hall.

Left An artfully reproduced painting on fusuma doors in the Shinden Hall's Willow-Pine Room.

Right A shaped *akamatsu* red pine is living garden sculpture.

Below A procession of monks at the Shoshin-den Hall.

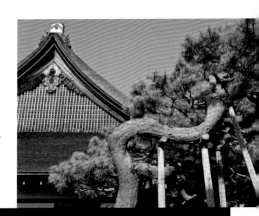

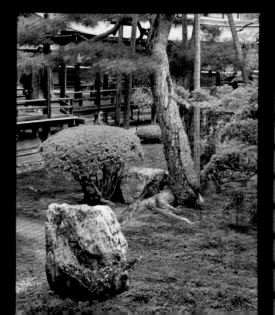

Tofuku-ji Temple

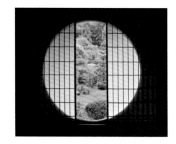

Left A tearoom's round window overlooks the garden at Funda-in Temple.

Below Komyo-in's immutable Zen garden was designed by Mirei Shigemori in 1939.

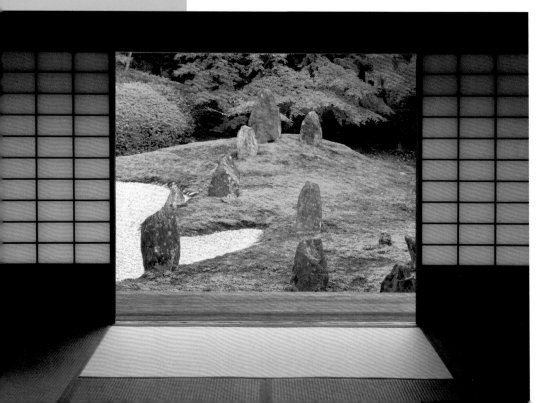

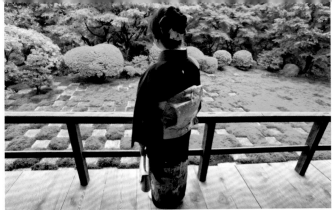

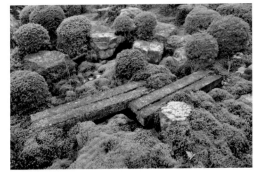

Established in 1236, Tofuku-ji is located just southeast of Kyoto Station in the Eastern Mountains. Noted author Donald Richie saw Tofuku-ji as "a massive Zen city," spreading around a mountainside ravine with covered wooden bridges and some two dozen subsidiary temples.

A single day is insufficient for even a cursory examination of Tofuku-ji's wealth of contemplative gardens and traditional Japanese architecture, including the two-story Sanmon Gate, a National Treasure that is the oldest Zen-style gate in Japan. The maple-filled gorge below the Tsuten-kyo covered bridge at Tofuku-ji is transformed into a technicolor Kyoto landscape each autumn.

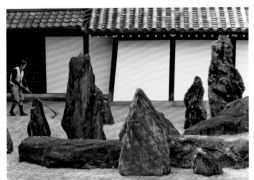

Above left An expert gardener at work by the Abbot's Hall.

Above The grid of vintage foundation stones and thick moss in the Hasso Garden is a transcendent blend of tradition and modernity.

Center left Granite blocks form a footbridge in the courtyard garden of the Kaisando Founder's Hall at Fumon-in.

Left Standing rock "mountains" in the Southern Hasso Garden.

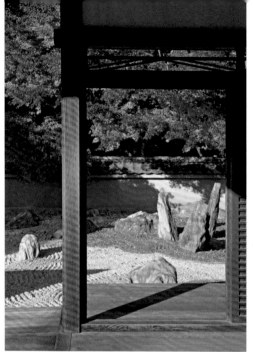

The main Abbot's Hall at Tofuku-ji and several of its sub-temples feature outstanding gardens by the 20th-century landscape architect Mirei Shigemori (1896–1975), who artfully blended traditional Zen elements and modernistic abstraction in garden designs that were instant classics upon completion. The Abbot's Hall is encircled by a selection of fine Shigemori gardens that are meticulously maintained and only grow more beautifully nuanced with age. The Engetsu-kyo covered wooden bridge leads to restricted entry at Ryogin-an sub-temple's Hojo Hall, another National Treasure, which is also surrounded by ethereal Shigemori creations, including the ironically spare "Garden of Vanity" and the "Dragon Garden" with its surprisingly dramatic stone dragon bursting through gravel clouds above a gravel sea.

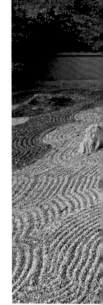

Above left The Hojo Abbot's Hall at Ryogin-an, ringed by gardens, is a National Treasure.

Below left Translucent shoji doors reveal pine needles embedded like watermarks in the hand-made *washi* paper.

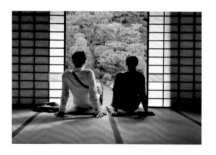

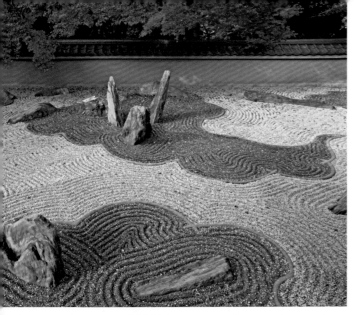

Left The Dragon Garden at Ryogin-an is a unique wonder to behold and a laborious challenge to maintain.

Below Sengyokukan Ravine is a magnificent valley of *momiji* maples.

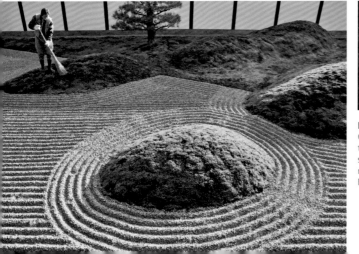

Left The Hasso Zen Garden reflects the modernist sensibilities of its respected creator, Mirei Shigemori.

Above A stone *chozubachi* basin with bamboo cover at Sokushu-in Temple.

Fushimi Inari Shrine

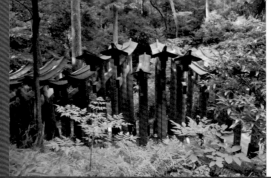

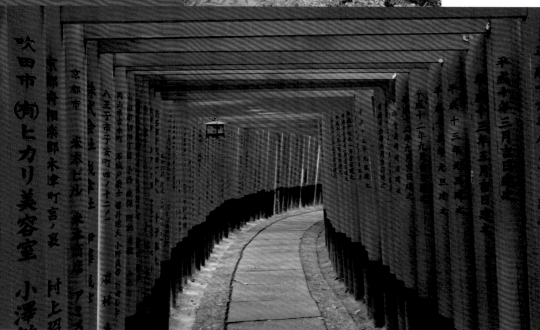

Left A torii gate path follows the natural contours of Mount Inari.

Below Each torii in this vermilion tunnel is inscribed for its Japanese business donor.

Below A bronze Inari fox with a rice granary key.

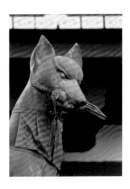

Known for its mountainside paths through 5,000 vermilion-lacquered torii gates, Fushimi Inari Taisha is a Kyoto icon. The shrine was founded in the 8th century and recently celebrated its 1,300th anniversary. Dedicated to Inari, the god of rice and fertility, the shrine's deities also insure business prosperity and safety. Each of Fushimi Inari's wooden torii gates was donated by a Japanese business enterprise seeking good fortune. Throughout the year, Fushimi Inari has an impressive calendar of Shinto ceremonies, purification rites, and traditional festivals to give thanks and seek harmony with nature and the deities. The transplanting of rice seedlings and the rice harvest are important seasonal rituals at the shrine. Millions of worshipers visit Fushimi Inari Taisha during the Japanese New Year.

The vibrant torii gates form tunnel-like passages of glowing red-orange luminescence up the slopes of Mount Inari, winding through the thick forest past smaller shrines and *kitsune* fox statues of bronze and stone. The wily fox, a benevolent but potentially tricky manifestation,

Top Red *chochin* lanterns enrich the shrine's radiance during the Motomiya Festival.

Above Torii gates lead the way to the mountain's summit.

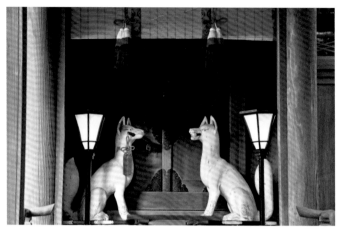

serves as messenger to Inari, and carries a granary key, a sheaf of rice grain, or a wish-fulfilling jewel in its mouth. Fushimi Inari Taisha is at its most strikingly spiritual and atmospheric in the quiet of dawn or at dusk, but be wary of any temptingly beautiful stranger that materializes in the subdued light of the sacred mountain.

Left Inari fox statues at the mountainside Tamayama Inarisha Shrine.

Below The Roumon Tower Gate.

Right A fox festival mask during the Motomiya Matsuri.

Below A *miko* shrine maiden in ceremonial robes.

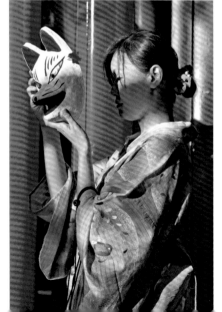

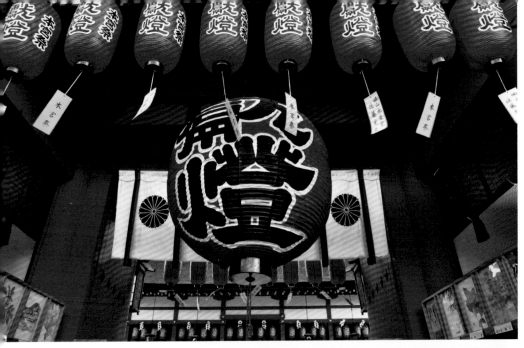

Above *Chochin* paper lanterns decorate the Roumon Tower Gate.

Right At dusk, beware the powers of enchantment.

Daigo-ji Temple

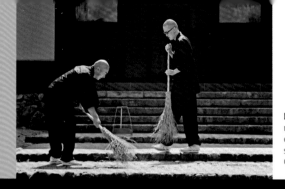

Left Novice monks sweep the entrance to their school at Denpo Gakuin.

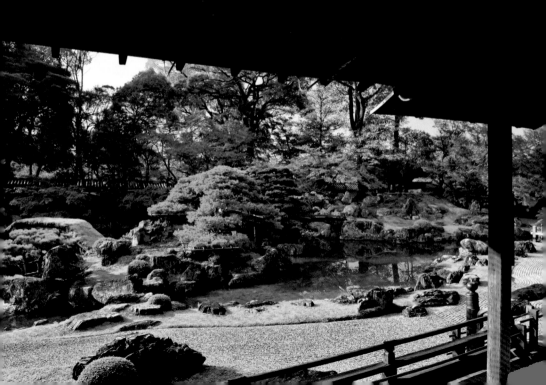

Daigo-ji Temple, a World Heritage Site, was founded in 874 during the early Heian period and named in honor of Emperor Daigo, who entered the Buddhist priesthood there after abdicating. Daigo-ji is located in the southeastern Fushimi district, and the temple grounds stretch from the foot of Mount Daigo, past Bentendo Hall and its picturesque pond, to the mountain's summit. The venerable temple possesses eighteen National Treasures, including an exquisite five-story pagoda, built in 951, that is the oldest wooden structure in Kyoto.

The eminently powerful warlord Toyotomi Hideyoshi (1537–1598), oversaw a restoration of Daigo-ji's subsidiary Sanbo-in Temple in 1598, creating a showpiece garden containing more than 700 carefully selected and artfully placed stones. The obsessively pristine garden of Sanbo-in, watched over by a vocal

Left The elegant Goju-no-To Pagoda was built in 951.

Below The ethereal Bentendo Hall in the lower Shimo-Daigo precinct.

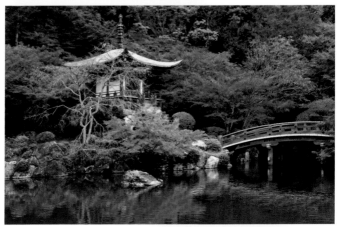

Left The Sambo-in Teien Garden was designed for viewing from the Omote Shoin Reception Hall.

Right A *tsukubai* tableau of stone basin, bamboo ladle, and aromatic Chinese quince at Sambo-in.

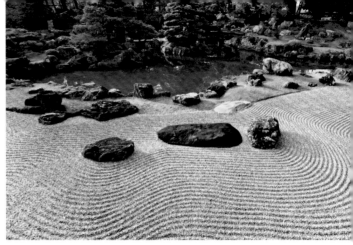

Below The lower
strolling garden
at Sambo-in.

Above The Teien
Garden's hundreds
of distinctive rocks
were each pain-
stakingly selected,
centuries ago.

Left Sambo-in
and its garden
are legacies of
the 16th-century
warlord Toyotomi
Hideyoshi.

Opposite below
Silky waterfalls
at the Bentendo
Hall's garden pond.

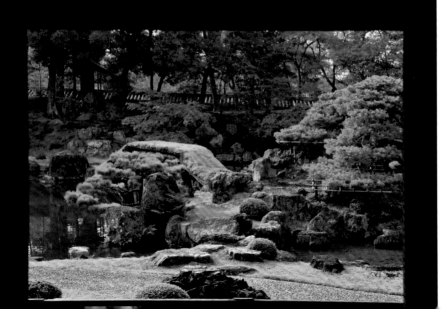

Below A stone relief *Fudo Myo* guardian deity.

Below right Silky waterfalls at the Bentendo Hall's garden pond.

Right A log-and-earth bridge covered with luxuriant moss is used only by Sambo-in gardeners.

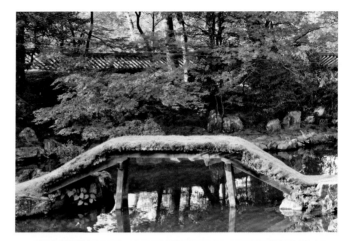

platoon of sharp-eyed attendants still worthy of any feudal lord, is especially gorgeous from any angle. A first glimpse can take one's breath away, and stepping back for a wider view only reveals more aesthetically pleasing details—*another* graceful bridge, *another* perfectly sculpted pine. The lower garden at Sanbo-in is more relaxed and less regimented and it is possible here to actually stroll amidst a pastel explosion of cherry blossoms in the early spring.

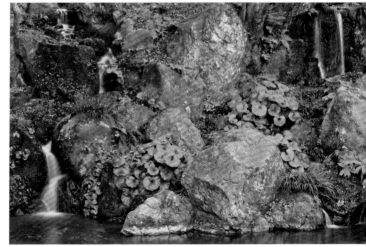

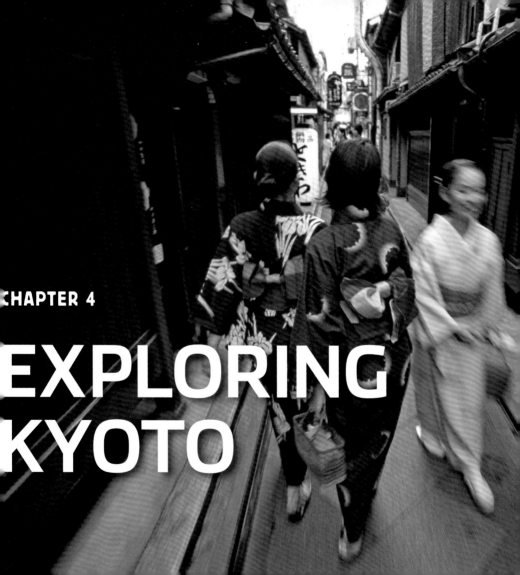

EXPLORING KYOTO

Kyoto was the largest city in Japan until the 16th century and remains among the ten biggest cities in the country today. The growing number of visitors to what has been repeatedly named the top travel destination on the planet strains an already stressed Kyoto transportation system. Two subway lines crossing in a simple axis seems an insufficient afterthought for a sprawling cityscape of more than 300 sq miles (777 sq km) that relies largely on a maze-like system of public bus routes ("Next stop, Horikawa Shimochojamachi!") for nearly 1.5 million people. Kyotoites take to their bicycles en masse and their trim fitness is testament to the daily biking and hiking of city streets.

For visitors, too, a bicycle is a wonderful way to explore Kyoto. Other strategies for investigating the ancient capital's centuries-deep layers of history and traditional culture involve focusing on reasonable routes that allow time for both the mind and feet to wander as one strolls. From the naturally refreshing distractions of the great city park of a river, the Kamogawa, to the forested mountains that surround the immense central basin of Kyoto, it is possible to experience natural beauty mixed with architectural and spiritual wonders within a day's outing. One can begin exploring the city immediately upon alighting from an arriving train, with a short trek from Kyoto Station.

The narrow Pontocho is an alley labyrinth of restaurants, bars, and teahouses that is especially alluring after sundown.

Kyoto Station Walkabout

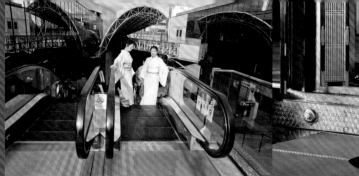

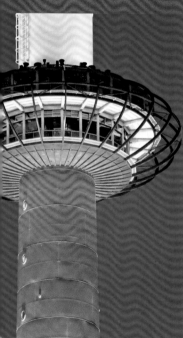

The huge, centrally located Kyoto Station, with its futuristic cubic glass façade and immense atrium, opened in 1997 to commemorate the 1,200th anniversary of the ancient capital. Not without a fight, though, as alarmed preservationists questioned the new station's proposed 15-story height and mammoth size. City fathers prevailed by pushing through special zoning allowances, and decades on the still shiny Kyoto Station warrants a closer look. Its vast atrium's Daikaidan "Great Staircase" may be one of the most human-friendly interior public spaces in all of Japan. Sample the station's atmosphere from a perch-like café seat or venture up the steep 7-story escalators or comfortable stairway to the Sky Garden's open-air terrace. Look due north onto the impressive clay tile roofs of some of the world's largest wooden structures at nearby Higashi Hongan-ji Temple.

Walk straight out of Kyoto Station's north exit, pass right by all the folks queuing for buses, and cross Shiokoji Street for an even higher panoramic view of the city from oft-criticized Kyoto Tower to

Left The observation platform of Kyoto Tower glows at twilight.

Above An intricately carved chrysanthemum, a symbol of longevity and rejuvenation, at Kosho-ji's Goeidomon Gate.

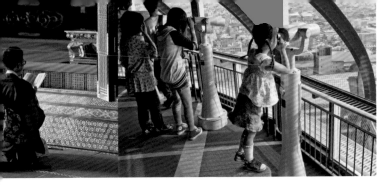

Far left Escalators are a popular option at Kyoto Station's Daikaidan "Great Staircase."

Center left Morning prayers inside Goei-do Founder's Hall at Kosho-ji Temple.

Left Color-coordinated visitors atop Kyoto Tower.

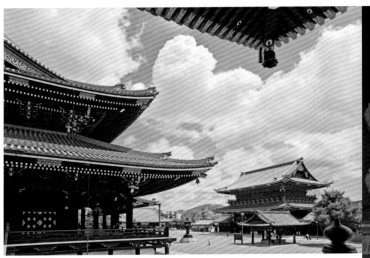

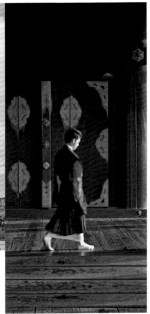

Above The Founder's Hall at Higashi Hongan-ji Temple is one of the world's largest wooden structures.

Right Nishi Hongan-ji's Amida Buddha Hall, a National Treasure, was rebuilt in 1760.

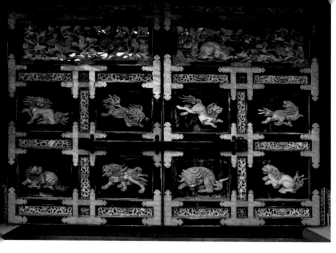

get your bearings. Or just continue north to the stunning gates of Higashi Hongan-ji. After many years of meticulous restoration, the temple's grand cathedral-sized halls are in beautiful condition, a striking physical memorial to the spiritual founder, Shinran, who dedicated his life to religious service and humbly referred to himself as an "ignorant bald-headed disciple of the Buddha." Higashi Hongan-ji's elegant detached Shosei-en Garden is located due east, and its rival, Nishi Hongan-ji Temple, with its many National Treasures, is a short walk due west.

Left Nishi Hongan-ji's Shoro Bell Tower.

Below A stone *toro* lantern and reflection of the Goju-no-To Pagoda at Toji Temple.

Far left Honden Hall visitors at Higashi Hongan-ji.

Left A young priest strikes the bronze Kansho Bell at Nishi Hongan-ji.

Right Crepe myrtle blooms by the Kaito-ro corridor bridge at Shosei-en Garden.

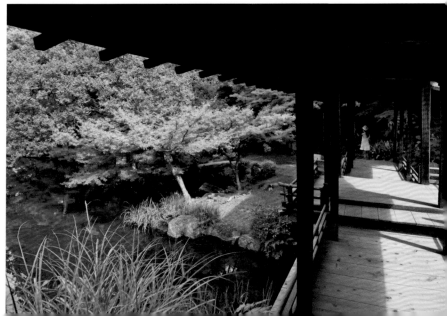

The Kamogawa River

From a pure source high on Mount Sajigatake in the north, the Kamogawa's cold clear waters flow many miles through Kyoto, with its wide riverbanks creating a splendid and informal park space, thus augmenting its mythical duties as the city's Blue Dragon eastern guardian. The river's democratic nature, relatively

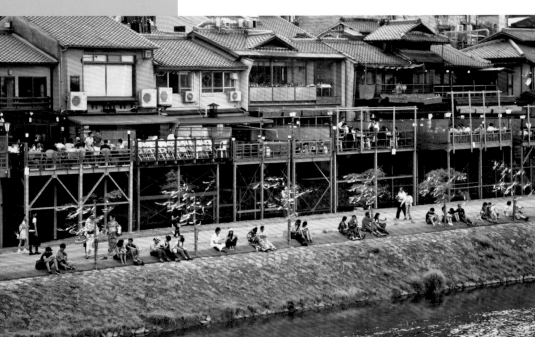

Left The Kitaoji-bashi Bridge, illuminated by traditional lanterns and contemporary traffic.

Below left Decorations for the Kyo-no-Hanabata summer festival line the river.

Right A cunning white heron fishes below a small waterfall.

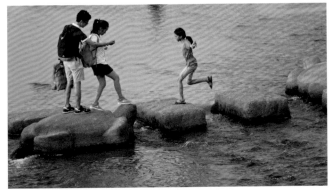

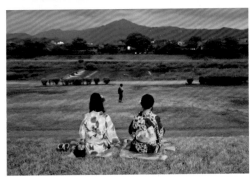

Above Turtle-shaped stepping stones span the river at Kamogawa Delta.

Left The river's west bank near Kuramaguchi affords an excellent view of Mount Hiei.

unfettered by rich estates or restrictive fencing, insures easy access for all and open vistas for unmatched cloud watching and distant mountain landscapes. Several possible lanes run alongside the Kamogawa like a virtual eco-highway, with the river itself as median, an upper path on both sides, then a lower main path of laid stone or sand above both riverbanks, and often a natural footpath meandering through the riverside grasses and clover.

The Kamogawa Delta, where the Takano River merges with the Kamo River at Demachiyanagi, is home to the Tadasu Forest of Shimogamo Shrine. The laid-back Kamogawa Delta river intersection just below increasingly attracts residents of all ages simply wanting to hang out, wade in the shallows, and relax. The Kamogawa's kaleidoscope of scenery changes by the day with the weather and season, featuring wild ducks, gulls, hawks, pigeons, raucous ravens, patiently fishing herons and egrets, and ink-black cormorants drying their wings in the river breeze. Musicians supplement the river's soundtrack of birdsong and waterfalls: guitarists, a man on sax, another on the flute. A young woman practising her bassoon under Kitaoji Bridge reverberates like a ship's horn.

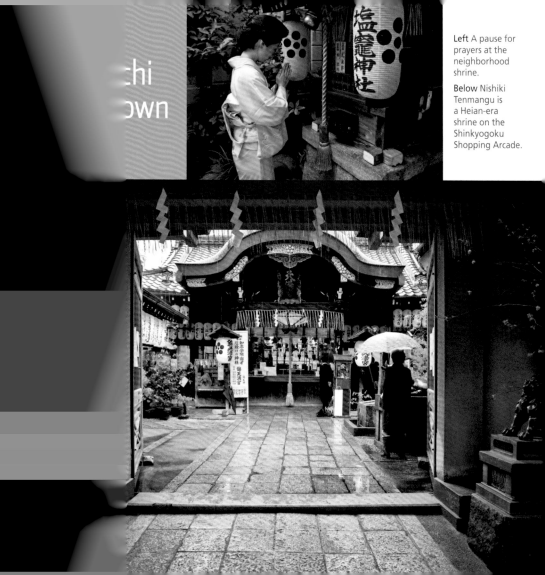

Left A pause for prayers at the neighborhood shrine.

Below Nishiki Tenmangu is a Heian-era shrine on the Shinkyogoku Shopping Arcade.

Teramachi "Temple Town" was established over 400 years ago by order of powerful warlord Toyotomi Hideyoshi (1537–1598), specifying the location of hundreds of temples and shrines. From the Meiji period Teramachi grew rapidly into a commercial center, with its famous Teramachi-dori Street now running through the heart of Kyoto's main shopping districts. Following

Below The serene interior of the Hondo Hall at Seigan-ji Temple.

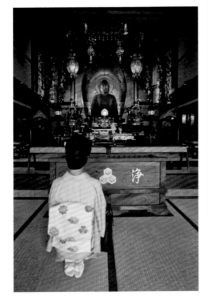

Above The display menu for a "family restaurant" on the Teramachi Shopping Arcade.

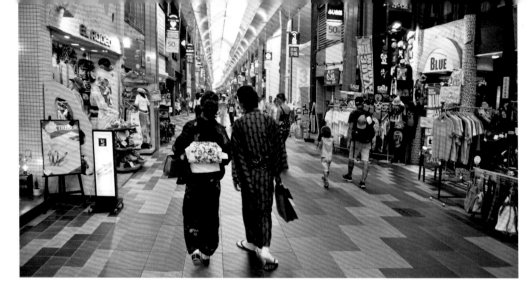

Above Nishiki's Aritsugu shop has been offering knives and cooking utensils since 1560.

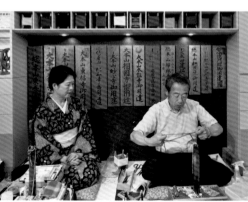

Above The roofed all-weather Shinkyogoku Shopping Arcade.

Left Yasuda Nenju Tan is an exclusive shop for Japanese *nenju* and *juzu* prayer beads, first established in 1683.

Right The market along
Nishikikoji Street is a
daily shopping festival.

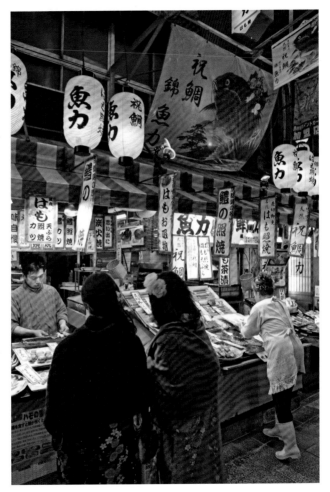

Teramachi-dori from its northern
end above the Imperial Palace to
its southernmost below the busy
avenue of Shijo-dori is an easily
navigated route for exploring Temple
Town and to accomplish some
shopping in the process.

The upper stretches of Teramachi-
dori are quiet, with the inviting
gates of surviving temples right
along the edge of the street. The
"Picture Frame Gate" of Tennei-ji,
a Zen Buddhist temple, perfectly
frames historic Mount Hiei, known
as Hiei-zan, on the eastern horizon.
Nearby Amida-ji Temple contains the
grave of Oda Nobunaga, the brutal
warlord infamous for his bloody
attack on the truculent temples of
mountain monks atop the very same
Hiei-zan in 1571. Teramachi-dori
skirts the eastern boundary of Kyoto
Gyoen National Garden's palatial
greenery before running down
past Kyoto City Hall and into the
covered Teramachi Kyogoku Arcade
of shops, where it intersects with
the enticing aromas and energy of
Nishiki Market's culinary street.

Kyoto by Bike

A great number of Kyoto residents depend on their bicycles for daily transportation, riding in any weather, every season, year round. Cycling to work or for shopping, they even grind out narrow, barely perceptible bike trails through the vast gravel avenues of the Kyoto Gyoen National Garden, like deer through a meadow. Visitors, too, can easily explore the city on a rental bike, especially the relatively flat streets and alleys of central Kyoto. Equipped with a simple bell and cargo basket, a bicycle can wonderfully transform one's perspective of the city and bring great relief to sore feet and tired shoulders. Whether following a carefully mapped-out plan or merely pedaling along until something amazing or just quirky catches the

Top A young mom with inquisitive toddler up front and necessary gear behind.

Above A Hanazono biker brakes for a peek in the front gate of Hokongo-in Temple.

eye, Kyoto by bike is a rolling wonder of cinematic vignettes.

The city has an impressive number of bicycle rental shops with quite reasonable rates, and many Kyoto hotels have bikes available as well. Considered to be a very bicycle-friendly city, Kyoto actually has a piecemeal bike lane system, so common sense must be used to safely navigate the busier city streets and sidewalks. Innocent pedestrians do not appreciate getting buzzed from behind without warning, and it is customary to dismount and push one's bicycle through arcades and other especially crowded venues. A bike light is mandatory at night. Consider any Kyoto bicycle journey as a worthy destination in itself.

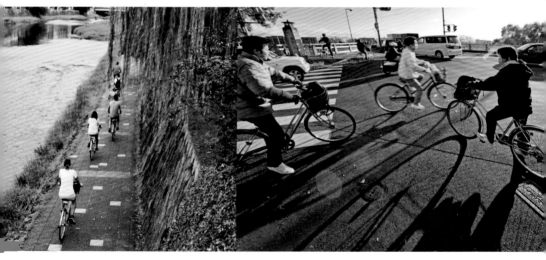

Above A column of foreign visitors pedal upriver on the east bank of the Kamogawa.

Above An early morning bicycle traffic jam at the Katsura River.

Top A family on two wheels zips alongside the Shirakawa River in Gion.

Gion

Kyoto's Gion district, located east of the Kamogawa River, is home to two very different centuries-old traditions. Gion's geisha, known as *geiko*, and their apprentice *maiko*, continue culturally refined entertaining and dining (and drinking) rituals in *ochaya* teahouses dating to the 17th century. Gion is also home to the monks and acolytes of Kennin-ji, the oldest Zen Buddhist temple in Kyoto, founded in 1202. Gion's iconic *maiko* and reserved Zen monks are elusive elements of equally esoteric disciplines, each requiring years of concentrated study and devotion.

The rare sight of even a single

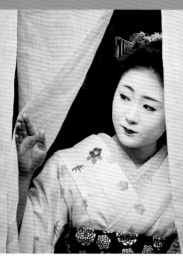

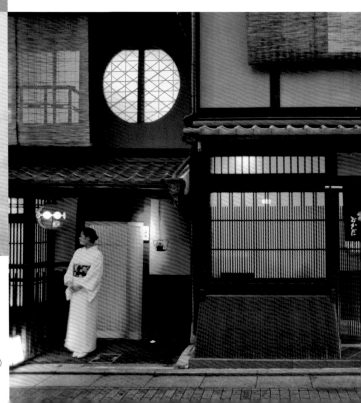

Above Perhaps this *maiko* is checking for tour groups before daring to set out.

Right The Hanamikoji district at the heart of Gion.

Far left An apprentice geisha checks her appearance.

Left A young couple cast their shadow on the 300-year-old Ichiriki teahouse.

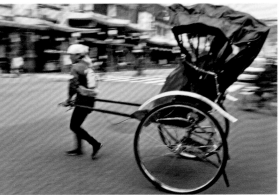

Above A rickshaw crosses Shijo-dori at the corner of Hanamikoji Street.

Left *Maiko* make their way to work along Pontocho Alley.

maiko in elaborate silk kimono with her distinctive matte white face and neck makeup and cherry-red lips, rushing to work along a Gion lane can cause such a commotion that the city has recently posted illustrated wooden signs urging tourists to leave the poor beauties in peace. Just a short walk from the landmark Ichirikitei, one of Gion's most renowned *ochaya*, unassuming earthen walls topped with clay tiles enclose the spacious temple grounds of Kennin-ji. Frequently unnoticed amidst Gion's more famous attractions and crowded lanes, the venerable Zen complex of exquisite gardens and ethereal atmosphere is somewhat ironically one of Kyoto's most inviting and peaceful temples.

Below A composed portrait at the Hojo Abbot's Hall.

Right Often overlooked, Kennin-ji, founded in 1202, is Kyoto's oldest Zen temple.

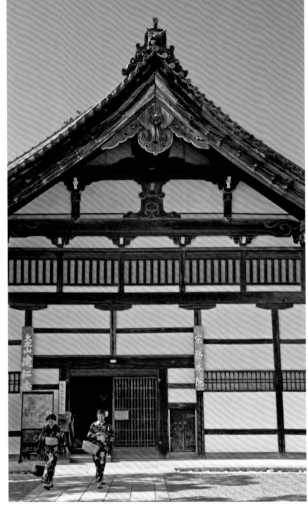

Right The Miyako Odori performance at Gionkobu Kaburenjo Theater is a seasonal sensation.

Below The Cho-no-tei Garden at Kennin-ji.

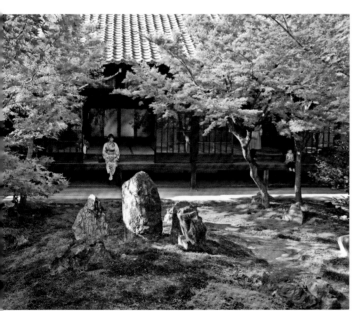

Above A pair of *maiko* promenade on Tatsumi-dori Street.

Higashiyama

Left It requires grace and stamina to brave the steep stone streets of Higashiyama in silk kimono and wooden *okobo* sandals.

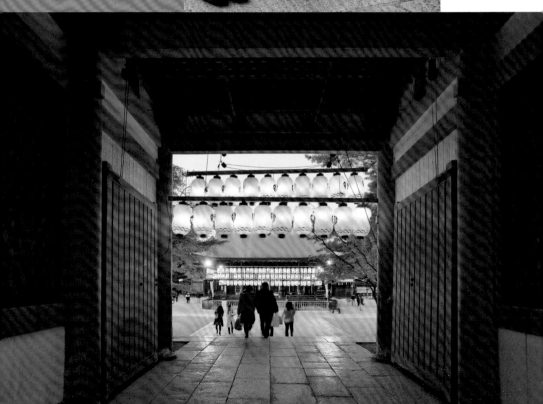

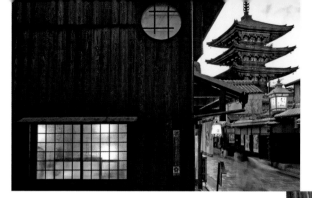

Above Yasaka Pagoda, a stalwart remnant of Hokan-ji Temple, is a Kyoto landmark.

Left *Chochin* paper lanterns brighten the early evening at Yasaka-jinja, a venerable shrine with a history dating to 656.

Higashiyama is named for the Eastern Mountains that form a natural green eastern border along Kyoto's great city basin. The Higashiyama district of stone streets is best explored on foot, from Kiyomizu-dera Temple to the south, along historic stone-paved Sannenzaka and Ninenzaka slopes lined with traditional shops, and past the iconic 5-story wooden Yasaka Pagoda. The cobblestone Nene-no-michi, a street named for Nene, the influential samurai wife of powerful warlord Toyotomi Hideyoshi, leads past Kodai-ji Temple, which was built by Nene as a Buddhist nun after her husband's death. Stone roadways continue into Yasaka-jinja, a 7th-century Shinto shrine that hosts the extravagant Gion Matsuri, a historic festival held each July, and dating back over a thousand years.

Further north from Yasaka Shrine and the adjoining Maruyama Park, laid out by the seventh-generation landscape gardener Ogawa Jihei VII and known for its remarkable cherry trees, the streets are quieter, passing below the monumental Sanmon Temple Gate of Chion-in

Top A *kannushi* priest updates donor plaques at Yasaka Shrine.

Above A narrow alley shortcut to the historic cobblestone Nene-no-michi Street.

Below A trinity of *maiko* proceed undaunted in broad daylight.

Right The striking silhouette of Yasaka Shrine's Honden Hall against a clear evening sky.

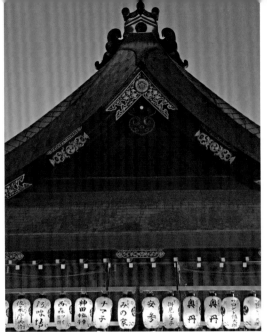

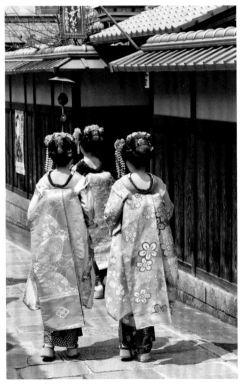

and the 800-year-old camphor trees of Shoren-in Temple to the east. The nearby Shirakawa River offers a gracefully curving route to follow, partially bordered with willow trees that trail delicate branches in the swift, clear water, and crossed by numerous footbridges leading to winding stone alleyways lined with traditional *machiya* townhouses of uniquely subdued Kyoto architecture.

Left The village-like garden complex behind Inoda Coffee features fine traditional architecture. The company's respected coffee heritage dates to 1947.

Below A monk in *takuhatsugasa* hat, indigo robe, and straw sandals strides uphill, bound for the temple grounds of Kiyomizu-dera.

Left An artistic gentleman on Chawanzaka slope.

The Philosopher's Path

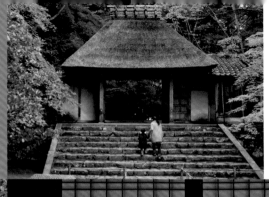

Left The thatched Sanmon Gate of Honen-in Temple.

Below left The Philosopher's Path follows the Shishigatani Canal.

Below Sliding shoji doors frame the fine garden at Anraku-ji Temple.

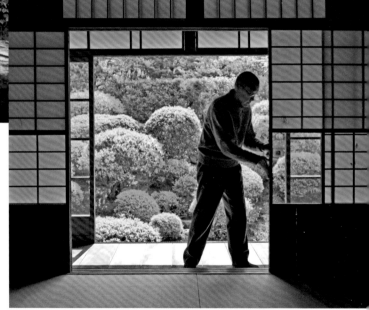

For exploring the northern district of Kyoto's Eastern Mountain foothills, one might begin near the Zen temple complex of Nanzen-ji, setting out from the southern end of the Philosopher's Path. Named after the prominent Japanese philosopher Kitaro Nishida (1870–1945), the simple path follows alongside the cherry tree-lined Shishigatani Canal, a part of the vital

Right Anraku-ji's main temple gate is opened for visitors in the spring and fall.

Below left A skillfully crafted bamboo railing borders the stone stairway to the hilltop lookout of Ginkaku-ji Temple.

Below right Camellia accents on a stone *chozubachi* basin in the temple garden at Honen-in.

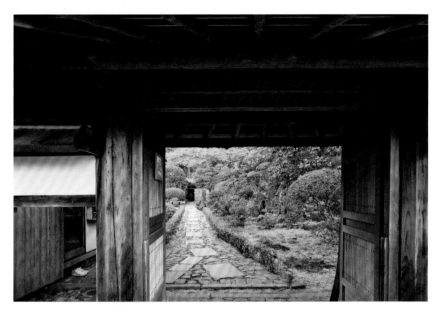

Lake Biwa Canal system. Professor Nishida, residing nearby, regularly strolled here, lost in meditative thought, or more purposefully on his way to work at Kyoto University.

The roughly 1 mile (2 km) Philosopher's Path is a pleasant trail through natural surroundings, and connects several outstanding historical temples. Passing below Honen-in, the unique stone-and-wood joinery of the secluded temple's lower gate

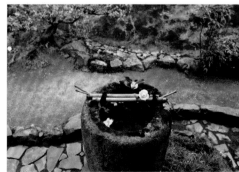

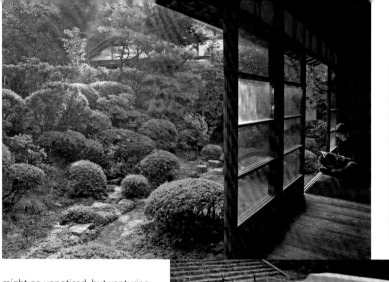

might go unnoticed, but venturing up Honen-in's stone walkway reveals a most impressive rustic thatched gate and Zen-like courtyard garden of sculpted sand mounds bordered with moss. At the northern end of the Philosopher's Path lies Ginkaku-ji, the "Silver Pavilion," originally constructed by Shogun Yoshimasu Ashikaga as a retreat from feuds, war, and financial misfortune. Now a World Heritage Site, contemplating the Zen temple's National Treasures in peace and quiet is a challenge equivalent to meeting a contemporary philosopher along the narrow path; one must be up and out before the sun rises or linger until the early evening owls echo in the wooded hills.

Above left The *engawa* veranda by Anraku-ji's autumn garden is a peaceful enclave.

Above A prime view from the Philosopher's Path shows the approach to Anraku-ji Temple.

Left The Byakusadan at Honen-in are sculpted sand mounds etched with subtle symbols of the season.

Right The elegant Kannon-den is Ginkaku-ji Temple's "Silver Pavilion."

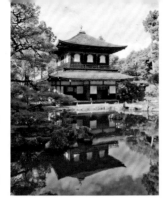

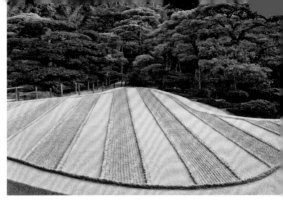

Far right The Ginsyadan is an evocative sculpted mound of silvery sand at the Ginkaku-ji Zen temple.

Below Covered wooden corridors encircle the courtyard garden at Anraku-ji.

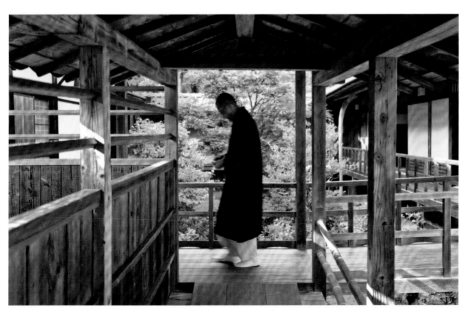

A Hermitage and a Poet's Retreat

Top right A folding *byobu* screen depicting Chinese sages at Manshu-in.

Above A gardener in a conical hat climbs stone steps between pristine hedges at Shisen-do Temple.

Right The thatched Basho-an cottage where the haiku master Matsuo Basho stayed at Konpuku-ji Temple in 1670.

The Ichijoji neighborhood in the northern foothills of the Higashi-yama district is remote enough from central Kyoto to retain some of the natural quietude that centuries ago attracted sensitive souls seeking solitude. The renowned haiku master Matsuo Basho (1644–94) visited Ichijoji in 1670, staying at

Left In Shisen-do's garden, a bamboo *shishi-odoshi* seesaw fountain is designed to scare away deer and wild boar when striking its stone base.

Below Fuku-chan, the temple's tabby cat, relaxes on the veranda at Konpuku-ji.

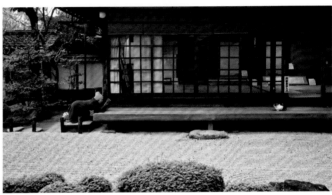

a thatched cottage on the hillside grounds of Konpuku-ji, a humble Zen temple, while wandering about Kyoto composing poems and writing in his journals. A century later, the haiku poet and painter Yosa Buson (1716–84) restored the cottage that had become known as Basho-an, preserving the simple retreat above

the Zen temple's garden as a memorial. Consequently, Buson's disciples buried him on the slope just above Basho-an. The sedate garden is now watched over by the temple's resident tabby cat, Fuku-chan, from the sunny veranda.

From Konpuku-ji, narrow streets zigzag uphill past the stone steps

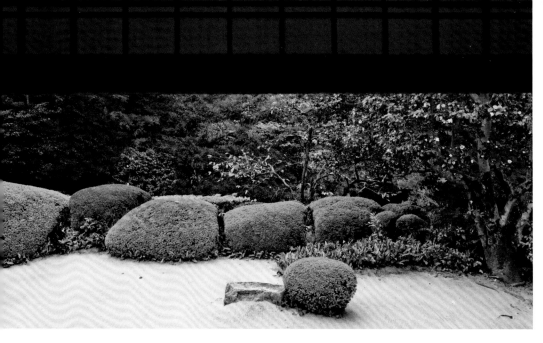

and understated wooden gate of Shisen-do, a tranquil thatched hermitage with refined gardens built by Jozan Ishikawa in 1641. The intellectual Jozan (1583–1672), a former samurai and shogun's aide-de-camp, spent the last decades of his life at Shisen-do, ultimately content as a reclusive artist and scholar. Further up, the increasingly steep road leads to Tanukidani Fudo-in, ensconced

Above Shisen-do's bare Zen garden contrasts with the autumn hubris beyond.

Left Alone by the garden, such an elusive luxury.

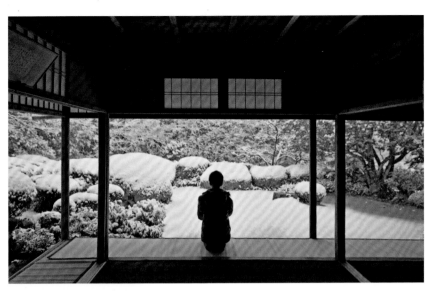

Left A winter sanctuary at Shisen-do.

Below left An awe-inspiring azalea framed by Shisen-do's rustic Robaikan Gate.

Below right A mountainside Kannon at Tanukidani Fudo-in Temple.

on the forested mountainside like a hidden citadel. Legend has it the supreme swordsman Musashi Miyamoto (1584–1645) sharpened his martial skills by a waterfall in the nearby woods. Mountain ascetic *yamabushi* priests add to the dramatic setting of contrasting eras when their *horagai* conch shells trumpet from the temple hall's imposing wooden veranda, with glimpses of the modern city in the distance far below.

Riding the Eizan Railway to Kurama

Left Eizan's Kurama Line passes through a tunnel-like canopy of autumn foliage.

Below Kurama-dera's Reihoden Museum has a spectacular perch.

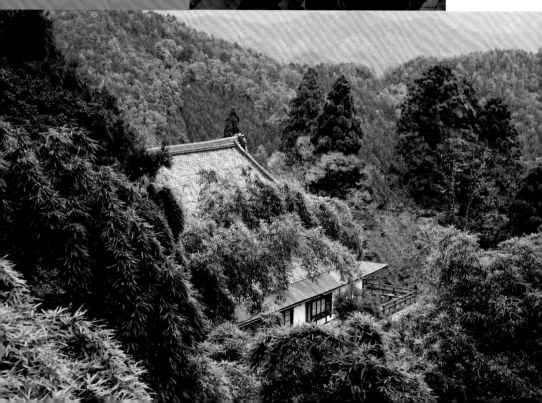

The small Eizan Railway network runs north from the Kamogawa and Takano River Delta at Demachi-yanagi, providing access to the Kichijoji foothills, the Shugaku-in Imperial Villa, and Takaragaike Park, where a northeastern spur leads to the cable car station for Mount Hiei. The Eizan's Kurama Line continues northward for the mountain villages of Kibune and Kurama, following the picturesque and secluded Kurama River Valley. The compact Eizan trains pass closely through a forest of maple trees that create a vibrant tunnel of warm swirling colors in the autumn.

A large bright red *tengu* goblin, mischievous long-nosed guardian of the mountains and forests, awaits arrivals at Kurama Station, the railway's terminus. A short cable railway leads partway up the steep, richly

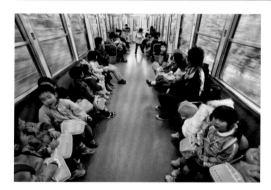

Top left The vermilion torii gate marking the road to Kibune Shrine blends with the seasonal hues of the forest.

Top right The remote temple garden at Entsu-ji incorporates the distant Mount Hiei.

Above Kids taking their local train home from school.

sacred cryptomeria trees. A beautiful gently curving road follows the sparkling river down to Kibuneguchi Station for a ride south to modern civilization back in central Kyoto.

Left A mischievous *tengu* guardian watches over Kurama Station.

Below An iridescent veranda view at the Amida Buddha Hall of Kurama-dera Temple.

forested mountainside to Kurama-dera, a temple founded in 770 as a wilderness refuge for meditation. Surrounded by striking mountain vistas, the meditative wildness endures. A splendid hiking trail winds up and down across Mount Kurama, seemingly right off the top of most Kyoto maps, making its roundabout way to the Kibune River Valley and the ancient Kibune Shrine set amidst

Far left Embarking from Kibuneguchi Station.

Left The rustic wooden Ninose Station is a clue that this train is headed deeper into the mountains.

Left A protective *Fudo Myo* stone relief along the hiking trail that crosses Mount Kurama.

Right Casual anglers wade in the clear river waters of the Takanogawa River below Mount Hiei.

Below Snowy stone stairs and traditional lanterns lead to Kibune Shrine.

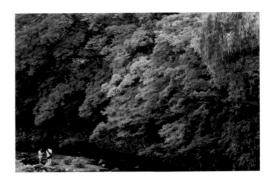

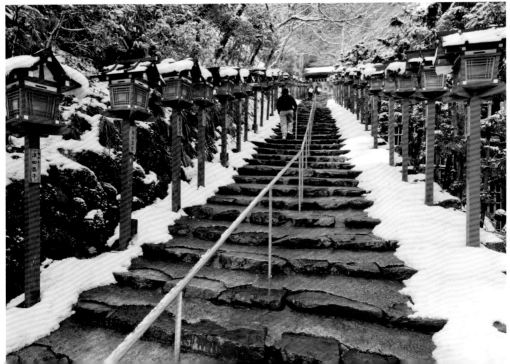

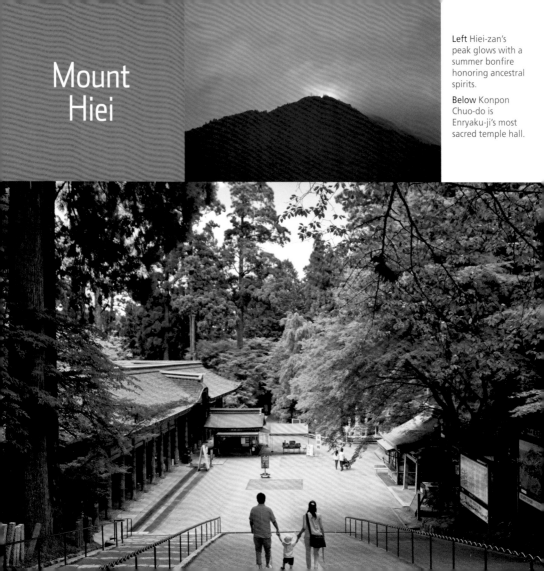

Mount Hiei

Left Hiei-zan's peak glows with a summer bonfire honoring ancestral spirits.

Below Konpon Chuo-do is Enryaku-ji's most sacred temple hall.

Mount Hiei, known as Hiei-zan, is one of the tallest peaks in the mountain ranges that surround Kyoto on three sides. Hiei-zan, with its distinctive profile visible from almost anywhere in the city, has been an important center for Tendai Buddhism and a critical historical foil of the ancient capital for more than a thousand years. Begun as a collection of mountaintop huts in the 8th century, Hiei-zan's Enryaku-ji Temple and monastery complex boasted 3,000 temple buildings and a veritable army of warrior-like monks at the peak of its influence.

Enryaku-ji grew perhaps too powerful and was completely destroyed by brutal warlord Oda Nobunaga in 1571. Reconstructed soon after, Enryaku-ji again thrives as a vital spiritual center spread in three main compounds across the mountaintop ridges and valleys of Hiei-zan, and is now a World Heritage Site. The Eizan cable car (the steepest in Japan) and ropeway ascend from the east

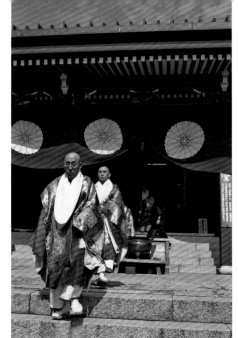

Top A bronze Buddha of Healing at the Amida-do Temple.

Above Autumn on the Takano River at the foot of Hiei-zan.

Above center Buddhist priests at Enryaku-ji's Great Lecture Hall.

Right The austere temple compound of Ganzan Daishi-do dates to the 10th century.

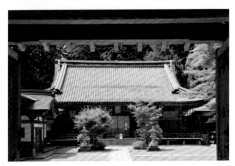

bank of the clear, rushing Takano River through the unspoiled wooded slopes of Mount Hiei. A short hike through the quiet forest, home to deer, wild boar, and monkeys, leads to cooler air accompanied by bird song and temple bells on the mountaintop, with sweeping views of Lake Biwa, Japan's largest freshwater lake, stretching away in the distance.

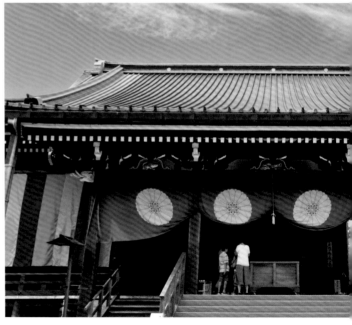

Top Silk *noren* curtains and flip-up *shitomido* shutters at the Great Lecture Hall.

Above A wooden alcove for *ema* votive plaques.

Right The Daiko-do, Enryaku-ji's Great Lecture Hall.

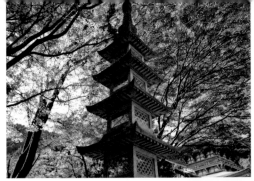

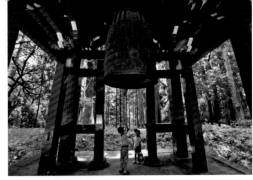

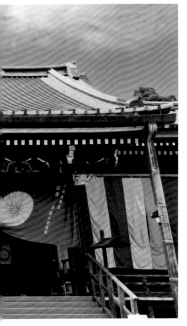

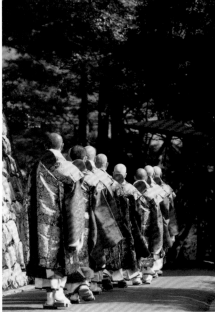

Above left A classic stone pagoda at Amida-do Temple.

Above Forest surrounds the Shoro Bell Tower in the Yokawa precinct.

Left A procession of Enryaku-ji monks clad in ceremonial robes.

Ohara

Ohara, in Kyoto's most remote northeastern area, is a farming community endowed with an exceptional array of remarkable temples. Located along the narrow road that ultimately winds on further north to the Japan Sea, Ohara has no train service, and buses from central Kyoto drive up through the Takano River Valley past rice fields and roadside shrines. From the modest Ohara bus terminal, a country lane along the Ryo River leads up to Sanzen-in, a spectacular mountainside of historic temple halls and sculpted gardens that began as an 8th-century hermitage. Trails above Sanzen-in curve past Raigo-in, constructed in 1200 as a training center for *shomyo* Buddhist hymnal chanting, to the delicate Otonashi Waterfalls, silent cascades of pure

Above The Hondo Hall of Shorin-in Temple, founded in 1013.

Left The abbot of Hosen-in points out planks, originally floorboards from historic Fushimi Castle bearing the bloodied imprints of valiant fallen samurai, reverentially reused in the veranda's ceiling.

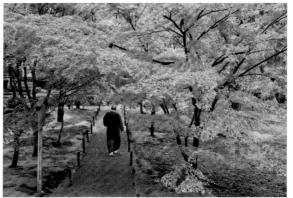

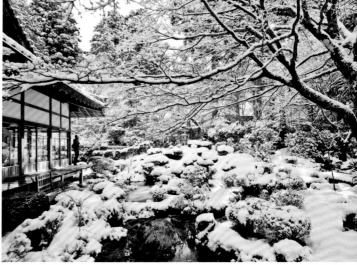

Above right The upper Yusei-en Garden at Sanzen-in Temple.

Right Sanzen-in's Kyakuden Hall and lower Shuheki-en Garden.

water over mountain boulders and weathered rockface on the Ritsu River.

The lane below Sanzen-in runs by Jikko-in, Shorin-in, and Hosen-in Temples. A 700-year-old pine tree skillfully shaped in the revered profile of sacred Mount Fuji can be glimpsed above the garden wall of Hosen-in, where the interior gardens are both elegant and meticulously maintained. Floorboards from Kyoto's historical Fushimi Castle, stained with the blood of loyal fallen samurai, are respectfully

incorporated as ceiling panels above the garden veranda at Hosen-in. Further afield, in Kochidani Valley to the north, the more rarely visited Amida-ji Temple is reached by a fragrant forest road that climbs into a scene from Shangri-La. Crystalline waterfalls lead upwards to the mountain temple just above, where Zen-like gardens and temple buildings of bare weathered wood overhang the hilltop plateau with unexpected perfection on the silent mountainside.

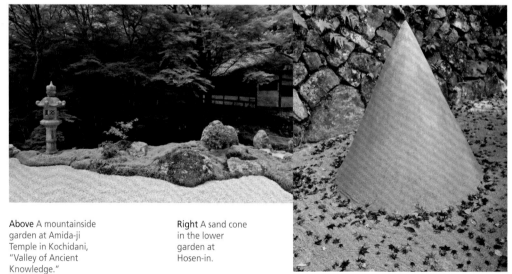

Above A mountainside garden at Amida-ji Temple in Kochidani, "Valley of Ancient Knowledge."

Right A sand cone in the lower garden at Hosen-in.

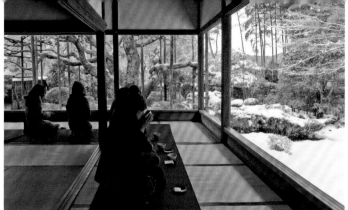

Top The Shoin Study at Hosen-in Temple.

Top right Warm winter tea at Hosen-in, a Tendai Buddhist temple founded in 1012.

Above A large clay *chatsubo* tea jar at Amida-ji Temple.

Right The cinnabar Suzakumon Gate at Sanzen-in.

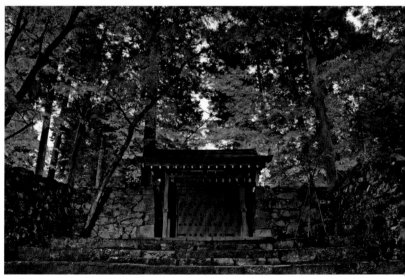

Temples of Lotus and Zen

Above A pink-red lotus, *Nelumbo nucifera*, in the Heian-era garden at Hokongo-in.

Top A young Zen monk at Taizo-in Temple.

Top right A splendid *onigawara* demon tile at Myoshin-ji's Buddha Hall.

One of Kyoto's finest lotus gardens is found inside Hokongo-in Temple, located directly across Marutamachi Street in front of JR Hanazono Station. Honkongo-in was established as a Buddhist temple in 1130 on the grounds of an ancient villa. Its garden stretches up from a lotus pond to the sloping base of Narabi Hill, where cascading spring water was used to create the oldest artificial garden waterfall in Japan. The waterfall's boulders now rely on water pumped from the garden's pond, where dragonflies hover amidst the pink and white lotus blossoms, the delicate flowers a sacred Buddhist symbol of purity and spiritual awakening.

The Hanazono district is named for Emperor Hanazono, who abdicated in 1318, and upon becoming

Top left Gardening chores at Myoshin-ji, a Zen temple complex founded in 1342.

Left A young Myoshin-ji monk carries an armload of rush.

Top The Seijo Taki at Honkongo-in is the oldest man-made garden waterfall in Japan.

Above A single lotus petal at Hokongo-in Temple.

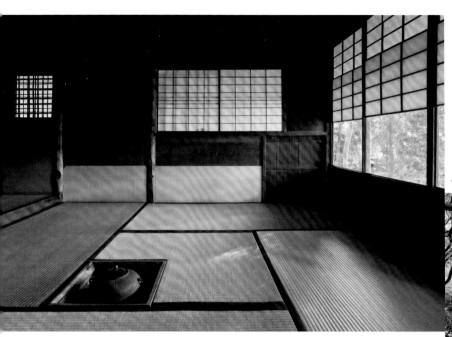

a monk donated his former palace grounds to establish Myoshin-ji, a Zen temple complex. Located just north from Hokongo-in's lotus pond, Myoshin-ji's 7 acres (3 ha) enclose numerous sub-temples whose Zen gardens spread around the classic south-to-north Zen temple layout: Sanmon Gate, Buddha Hall, Dharma Hall, and Abbot's Hall. The temple's winding stone lanes are flanked by high walls and graceful temple roofs that create a showcase of artistic *kawara* clay roof tiles, including *onigawara* demons, *komainu* lion-dogs, and imperial chrysanthemums. The narrow stone paths are used by Zen priests, busy acolytes, and neighborhood kids just taking a short cut.

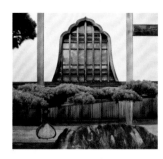

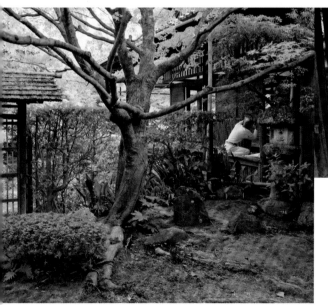

Top A stone weight and bamboo splint are used to shape a pine tree's limb at Kingyu-in.

Above *Noren* curtains at the entry gate of Daiho-in.

Left A specialist *tateguya* craftsman repairs a sliding door at Keshun-in.

Arashiyama and Sagano

The northwestern Kyoto districts of Arashiyama and Sagano are a wonderful area to wander, if not initially too distracted by Tenryu-ji, the 14th-century Temple of the Heavenly Dragon, a World Heritage Site. The outstanding architecture and gardens of Tenryu-ji can be overwhelming, even before consid-

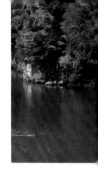

Right A small excursion boat floats placidly down the Hozu River Gorge.

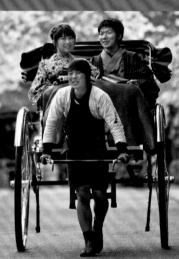

Above A spring rickshaw ride to view the cherry blossoms.

Right The Tekisuian teahouse at Okochi Sanso, a garden villa on Mount Ogura.

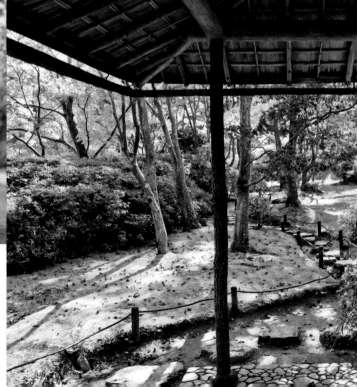

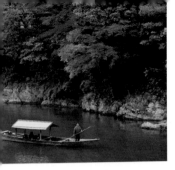

ering its nearby Hogon-in subsidiary temple with gardens built around giant boulders naturally "placed" by the course of the Hozu River. Hogon-in's fine gardens are only recently accessible after being closed to the general public for 140 years. Crossing the landmark Togetsukyo Bridge and following the footpath upstream along the Hozu River leads to Daihikaku Senkon-ji, a seldom-visited mountainside temple perched alone, a moody sentinel above the gorgeous river valley.

Northeast from Tenryu-ji, narrow roads lead to Okochi-Sanso, a period film star's personal Zen dream expressed in the villa's artfully

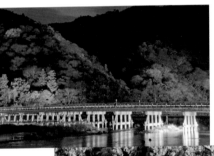

Left The artistic form of the Togetsukyo Bridge over the Katsura River is emphasized by evening illumination.

Below Ripe *kaki* persimmons hang over the thatched Rakushisha, "Cottage of Fallen Persimmons," where Matsuo Basho wrote his *Saga Diary* in 1691.

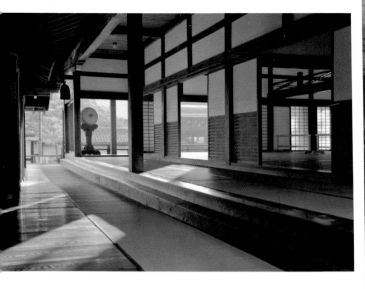

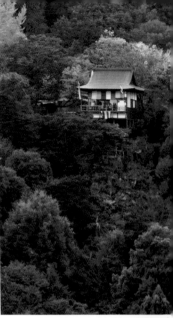

disciplined landscapes on Mount Ogura. Continue through farm plots into Sagano, and eventually a distinctive thatched roof and heavily laden persimmon trees appear above an *ikegaki* evergreen hedge at Rakushisha, the hermitage where the master poet Basho wrote his *Saga Diary*. Inside, Rakushisha's dim interior of functional simplicity might inspire a haiku, completed by the sound of a persimmon falling in the garden. Back on a crowded lane

Above Tenryu-ji Temple's large abbey, the Daihojo, was completed in 1899.

Above right Daihikaku Senko-ji Temple clings tenaciously to the mountainside above the Hozu River Gorge.

near Arashiyama Station at twilight, an older crossing guard calls out as if from a different time: "The full moon is rising in the eastern sky, the full moon is rising in the eastern sky...."

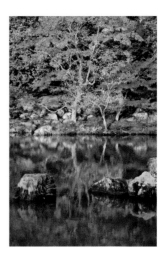

Right The Sogenchi Garden at Tenryu-ji was originally designed by the renowned Zen monk Muso Soseki in the 14th century.

Below left *Matcha* green tea served on the veranda of the Muian teahouse at Hogon-in Temple.

Below center The Chumon Gate at Okochi Sanso, a garden villa with a remarkable variety of stone footpaths.

Below right Uniformed high school students meet *maiko* apprentice geisha at Togetsukyo Bridge.

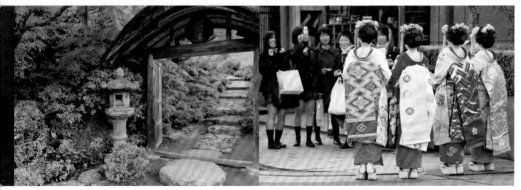

Uji

Left A statue of noblewoman Murasaki Shikibu, author of *The Tale of Genji*, who is considered to be the world's first novelist.

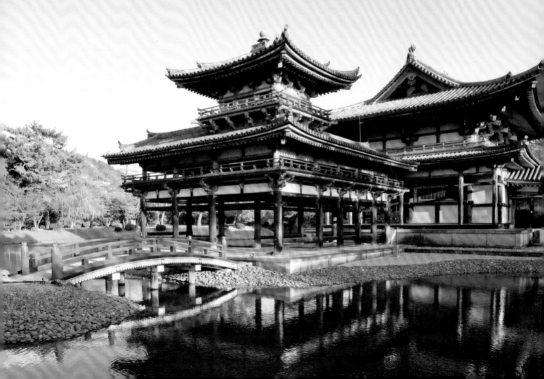

Below left The Phoenix Hall at Byodo-in Temple, built in 1053, is an architectural embodiment of celestial enlightenment.

Right A demonstration of traditional *ugai* cormorant fishing in a channel of the Ujigawa River.

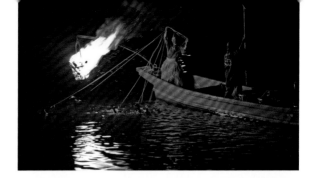

Historic Uji is located south of Kyoto on the Uji River, which flows in a torrent from Lake Biwa. Known for its fine tea cultivation since the 14th century, Uji *ocha* can be sampled at the riverside Taihoan, the Uji City Municipal Tea Ceremony House. Demonstrations of traditional cormorant fishing are held by firelight along the river on summer evenings. Across the river to the north is Ujigami-jinja, a World Heritage Site that is the oldest extant Shinto shrine in Japan, and close by is the Tale of Genji Museum. Written in the early 11th century and considered the world's first novel, the final ten chapters of noblewoman Murasaki Shikibu's *The Tale of Genji* were set in Uji.

Near the Uji River's southern bank lies another World Heritage

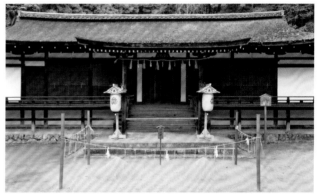

Above The Haiden at Ujigami Shrine is the oldest Shinto worship hall in Japan.

Right The Tale of Genji Museum celebrates the namesake 11th-century novel, especially the chapters set in ancient Uji.

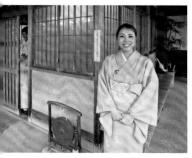

Above Charming tea hosts at Taihoan, a municipal teahouse that serves famous Uji *ocha*.

Right A refreshing breeze on a bridge connecting islands in the Uji River.

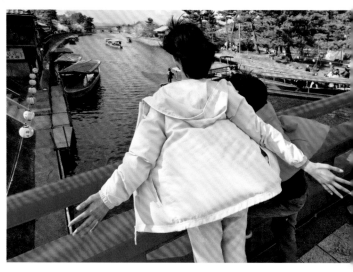

Left A pilgrim monk at Mimuroto-ji Temple.

Site, Byodo-in, perhaps the ultimate in refined architectural design and spiritual expression. The 11th-century temple's Phoenix Hall, with its lone Amida Buddha and corridor wings, seems a floating celestial dream reflected in the liquid mirror of the garden pond. Recently restored, Byodo-in's fresh lacquer will age for decades, growing ever more beautiful with the patina of time and the elements, as will the pair of shiny gold phoenix ornaments atop the roof of perfect new

Below Azaleas add color to the *karesansui* dry landscape garden at Mimurodo-ji.

Right A tranquil garden deck by the Hoshokan Museum at Byodo-in.

kawara clay tiles. Displayed in the temple's Hoshokan Museum amidst other priceless treasures, the original phoenix sculptures, with their ancient patched repairs, are heartbreakingly beautiful.

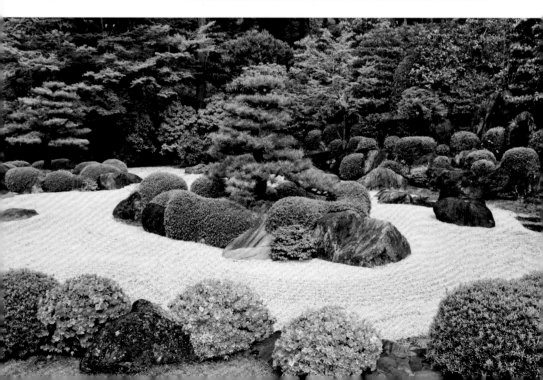

Lake Biwa

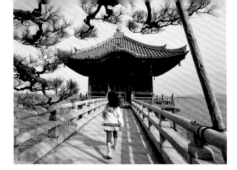

Left Branches of a 700-year-old black pine frame the pavilion of Ukimido, the "Floating Temple," which extends out over the lake at Katata.

Below The Tenbin-yagura Tower at Hikone Castle, a National Treasure on Biwako's eastern shore.

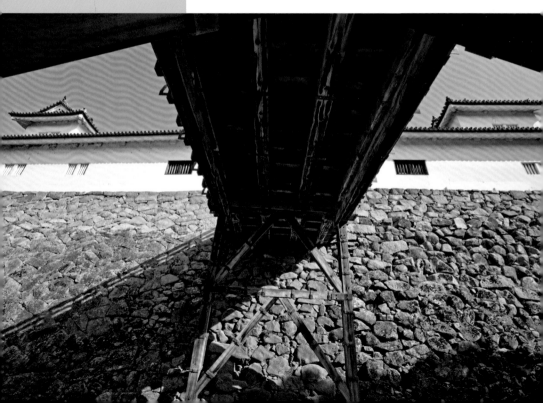

Far left A lakeside restaurant in the old port town of Katata.

Left The Shinto torii gate of Shirahige Shrine stands *in* the waters of Lake Biwa.

Below The freshwater tunnel tank aquarium at the Lake Biwa Museum.

Few Kyoto visitors catch even a fleeting glimpse of Lake Biwa, known as Biwako, from the window of their high-speed Shinkansen train as it rapidly approaches the ancient capital of Kyoto just a few miles beyond the Higashiyama Mountains. Biwako, Japan's largest freshwater lake, covering some 260 sq miles (673 sq km), has many connections to Kyoto, though, both historical and geographic. The lake's higher elevation enabled the vital Lake Biwa Canal project in the 1890s, a boost to Kyoto's industry and morale after the emperor's departure for Tokyo. Kobori Enshu (1579–1647), the great Kyoto architect and garden designer, was a *daimyo* lord along Biwako's western shore. On the eastern shore, the elegant fortress of Hikone Castle is a National Treasure.

Classic scenes of fish traps, like delicate designs sketched in the lake's waters, or distant mountains fading into paler tones range by range, can be found in the more remote northern regions of Biwako. There, too, lies the sacred island of Chikubu, a destination for religious pilgrims dressed all in white. An especially beautiful scene still graces the southwest shore at Katata, where the Ukimido "Floating Temple" pavilion hovers over the lake on pillars, reached by a stone footbridge. The peripatetic poet Matsuo Basho visited it in 1690, intent on beholding the full moon from Ukimido. Contemporary efforts are under way in Katata to revive the lake's freshwater pearl culture industry, where once 20th-century "Biwa Pearls" were considered the most beautiful in the world.

Nara

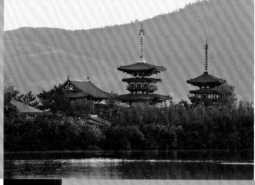

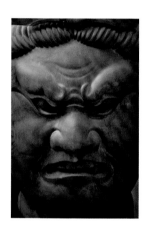

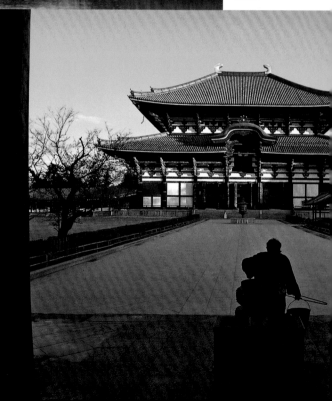

Above An impressively fierce guardian deity statue glowers inside the Great Buddha Hall at Todai-ji Temple.

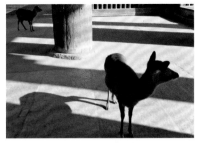

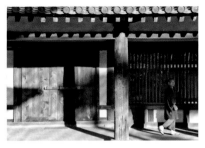

Far left Sacred *sika* deer at Todai-ji's Nandaimon, the Great South Gate.

Left The Cloister Gallery at Horyu-ji Temple.

Bottom The precious Goju-no-To Pagoda at Horyu-ji is one of the world's oldest wooden structures, dating to the early 7th century.

A pleasant hour's train ride from Kyoto, Nara is the capital city of Nara Prefecture, located on the mountainous, forested Kii Peninsula. Nara was Japan's first permanent imperial capital in the 8th century, over 1,300 years ago. Nara's great Buddhist temples retained power and influence even after losing their imperial status, and the city is still blessed with some of Japan's most splendid Buddhist monuments within its Ancient Nara World Heritage Site. Nara is perhaps best known for Todai-ji Temple's Daibutsuden, the world's largest wooden building, which contains the 49 ft (15 m) high Great Buddha, the world's largest bronze casting. It is estimated some 2,600,000 people aided in the construction of the Great Buddha and its Hall, contributing food, materials, and labor. The surrounding green of

Nara Park also encompasses Kasuga Taisha, one of Japan's most sacred Shinto shrines, and is home to more than 1,200 wild *sika* deer. The docile spotted creatures are regarded as divine messengers and some will bow politely for cervine *osembe* snacks.

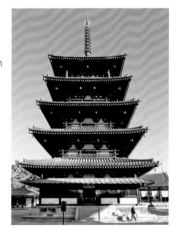

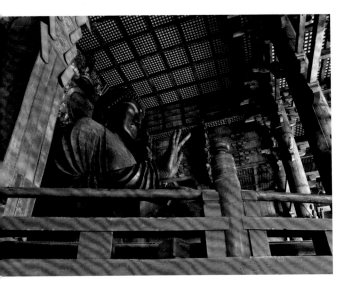

Opposite above, left to right The Ikeda Gankodo shop for traditional Japanese fans is a 150-year-old family business; The *tsuboniwa* courtyard garden at Awa, a *machiya* townhouse restaurant; A congregation of stylish women in the old Naramachi merchant district.

Just to the southwest, Nara's Horyu-ji Temple features the oldest wooden buildings in the world, dating to the early 7th century. Research indicates that the central pillar of Horyu-ji's elegant pagoda was fabricated from a tree felled in 594. Other historical locations can be more easily explored on a walking tour of old Naramachi (Nara Town), south of Sarusawa Pond, where the once-extensive temple grounds of the thriving 8th-century Gango-ji were developed into a merchant district. Naramachi, with its distinctive red monkey-shaped *migawarizaru* charms hanging under residential eaves to ward off evil, has several traditional *machiya* town houses and artist studios open to visitors. Noted author Pico Iyer, a long-time resident, finds that Nara "has a changeless grandeur … the rare place in Japan that is sleepy, traditional and quite private, yet saturated with history." Nara certainly offers much more than can be absorbed on a single day trip from Kyoto.

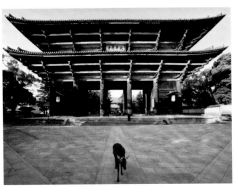

Above The Great Buddha inside the Daibutsuden at Todai-ji is the largest bronze casting in the world.

Left The Great South Gate at Todai-ji was completed in 1203.

Opposite below The Nandaimon Gate at Horyu-ji Temple.

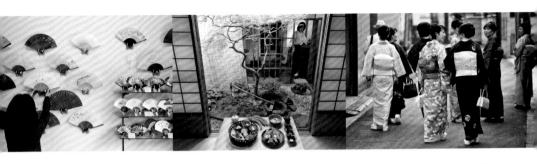

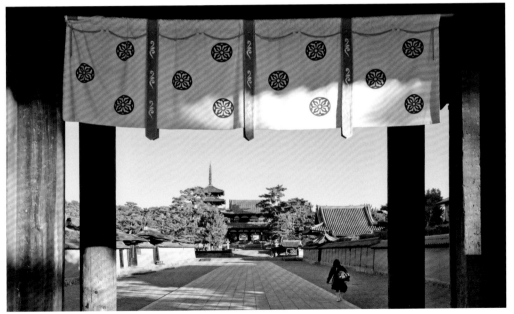

Published by Tuttle Publishing, an
imprint of Periplus Editions (HK) Ltd

www.tuttlepublishing.com

Copyright © 2018 Ben Simmons
Photography

ISBN: 978-4-8053-1447-0

Distributed by
**North America, Latin America
& Europe**
Tuttle Publishing
364 Innovation Drive
North Clarendon, VT 05759-9436
U.S.A.
Tel: 1 (802) 773-8930
Fax: 1 (802) 773-6993
info@tuttlepublishing.com
www.tuttlepublishing.com

Japan
Tuttle Publishing
Yaekari Building, 3rd Floor
5-4-12 Osaki
Shinagawa-ku
Tokyo 141-0032
Tel: (81) 3 5437-0171
Fax: (81) 3 5437-0755
sales@tuttle.co.jp
www.tuttle.co.jp

Asia Pacific
Berkeley Books Pte. Ltd.
61 Tai Seng Avenue, #02-12
Singapore 534167
Tel: (65) 6280-1330
Fax: (65) 6280-6290
inquiries@periplus.com.sg
www.periplus.com

21 20 19 18 5 4 3 2 1

Printed in China 1807RR

TUTTLE PUBLISHING® is a registered
trademark of Tuttle Publishing, a
division of Periplus Editions (HK) Ltd.

Taihoan is a very
attractive teahouse
in historic Uji.